illustration school

let's draw a story

sachiko umoto

QUARRY

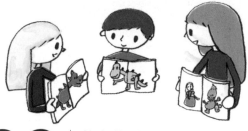

Brimming with creative inspiration, how-to projects, and useful information to enrich your everyday life, Quarto Knows is a favorite destination for those pursuing their interests and passions. Visit our site and dig deeper with our books into your area of interest: Quarto Creates, Quarto Cooks, Quarto Homes, Quarto Lives, Quarto Drives, Quarto Explores, Quarto Gifts, or Quarto Kids.

Inspiring | Educating | Creating | Entertaining

Copyright © 2015 Sachiko Umoto.
Originally published in Japan in 2015 by BNN, Inc.

First published in 2015 by Quarry Books,
an imprint of The Quarto Group,
100 Cummings Center, Suite 265-D,
Beverly, MA 01915, USA.
T (978) 282-9590 F (978) 283-2742
www.QuartoKnows.com

Quarry Books titles are also available at discount for retail, wholesale, promotional, and bulk purchase. For details, contact the Special Sales Manager by email at specialsales@quarto.com or by mail at The Quarto Group, Attn: Special Sales Manager, 100 Cummings Center, Suite 265-D, Beverly, MA 01915, USA.

Library of Congress Cataloging-in-Publication Data available

ISBN: 978-1-63159-093-1

10 9 8 7

Page Layout: tabula rasa graphic design
English Translation: Allison Markin Powell

Author: Sachiko Umoto
Original Design: Yuri Nakatani
Original Layout: Masahiko Hirano
Planning/Editor: Tomoya Yoshida

Printed in China

MIX
Paper from
responsible sources
FSC® C016973
www.fsc.org

What Kind of Book Is LET'S DRAW A STORY?

Dear Reader,

People often ask me, "How do I get better at drawing?" I never know how to answer, because I'm not very good at it myself. But I enjoy drawing. The best way to take pleasure in it is simply to put your heart and soul into it, and just draw!

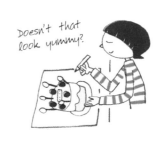

Doesn't that look yummy?

In this book, I've created a story that I hope will appeal to readers and inspire them to create their own heartfelt story. Even if you copy the drawings or trace the designs, each version will be different—it will never be the same story twice! Imagine your own scenarios, choose whatever colors you prefer, express yourself however you like. You will create your very own storybook.

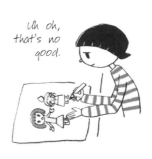

Uh oh, that's no good.

By drawing your own world, it becomes part of reality and connects it to the world that we all share. Try showing it to someone and saying, "Look what I drew?" You can make connections with lots of people by sharing the joy of creating something with your own hands. It's bound to make everyone happy.

Sachiko Umoto

Wham! Boom!

Sparkle....

Ah, I'm so happy!

TOOLS FOR DRAWING A STORY

You don't need to have all of these on hand.
Use what you have, or whichever ones you like.

Pencil

You can draw and draw to your heart's content, since you can erase and do it over as many times as you like. Get a soft line by drawing gently, or get a hard line by drawing firmly.

Mechanical Pencil

You always get a sharp line. You can erase it too. And it's nice not to have to sharpen it.

Ballpoint Pen

These aren't erasable, but it's fun to just see what you happen to draw. You can enjoy rolling around the fine point—try lots of colors.

Felt-Tip Pen

These make a squeaky sharp line, and you can draw over other work. I like the way you can layer colors and they bleed into each other. But if you layer too many colors, the paper can tear.

Colored Pencil

Just like with a lead pencil, you can get a thin line by pressing gently, or a thick line by pressing firmly. You can get a beautiful finish as long as the tip isn't too sharp.

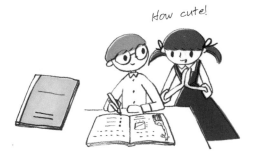

How cute!

Notebook

Use any free space to draw, as long as it doesn't interfere with your studies or your work. Your friends might even see and praise your drawing. If the ruled lines bother you, just pretend they aren't there.

Sketchbook

Take advantage of drawing on a wide-open canvas. This paper is perfect for drawing with pencils or using paint.

Don't move

Memo Pad

Lightweight and easy to carry, these are great for scribbling away. You can draw on the train, or while you're drinking coffee—whenever the mood strikes you!

Eraser

An eraser is a pencil's trusty friend. Use the broad side for large areas, and the edges for smaller spots—you can even use a utility knife to make smaller erasers. Be careful not to rub too hard though, so as not to rip or tear the paper.

We're being erased! Run for your life!

Sweep the wide part when erasing big areas

Cut the eraser with a utility knife to get an edge for erasing smaller areas

THE BASICS OF THE BASICS

Learning some basic skills helps make drawing easy. But, remember, the basics are nothing more than a fundamental starting point.

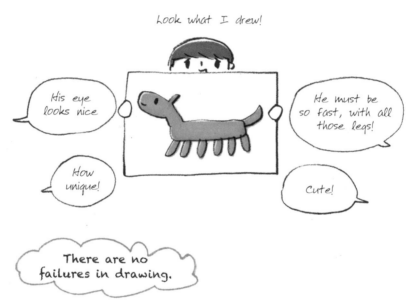

Look what I drew!

His eye looks nice

He must be so fast, with all those legs!

How unique!

Cute!

There are no failures in drawing.

Not even the artist really knows how a drawing is going to turn out.

Sometimes it comes out just how you expected, but sometimes it doesn't.

When that happens, please don't assume that's a failure.

Because it might still turn out to be a lovely drawing!

Show it to other people—they may find certain charms that you never even realized were there!

Wondering where to start?

1 Draw larger shapes first

[Draw the head before you draw the eyes or the nose, draw the body before you draw the hands, feet, or other patterns.] Try to get an idea of the overall shape before you add the fine details.

Draw the silhouette of the dress first *Then draw the decorative details*

2 Draw from top to bottom, right to left

Pick up your pen or pencil and try waving it around. Can you feel how natural it is to move it from top to bottom or right to left? (Or left to right, if you are left-handed!)

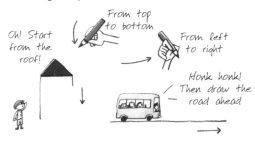

Oh! Start from the roof! *From top to bottom* *From left to right* *Honk honk! Then draw the road ahead*

3 Draw the head before the body

When you draw the head, you can get a feel for your character's personality and what it is probably thinking at the time. This makes it easier for you to decide how to draw the rest of the body.

This girl looks lively, and I bet she likes to draw! → *So let's give her a pencil!* *Sleeves rolled up cheerfully* *Standing in a power pose*

* The Basics Can Be Contradictory

Sometimes the basics described in steps 1, 2, and 3 will seem to contradict each other, and you may have a hard time deciding where to start. If that's the case, just start wherever you want.

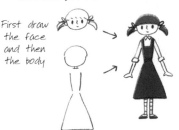

First draw the face and then the body *Once you have the shape of the body, then you can add the details*

4 Apply different pressures to the tip of your pen

Press hard when you draw the solid parts and lightly when you draw the soft parts. You can draw a lot of different lines with the same pen just by applying different amounts of pressure.

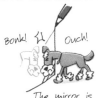

Bonk! *Ouch!*

The mirror is hard and solid *The cushion is soft* *Leave uncolored* *Gently shade with gray* *Color in strong black*

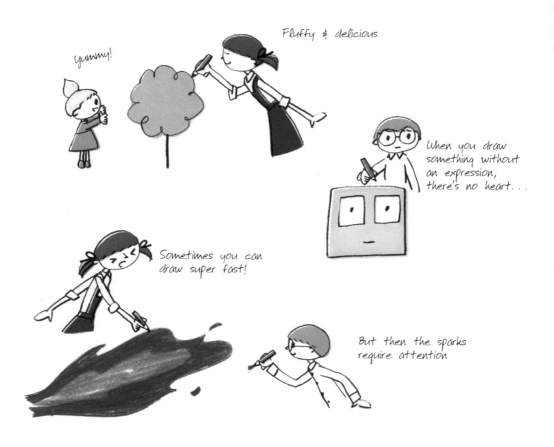

Yummy!

Fluffy & delicious

When you draw something without an expression, there's no heart. . .

Sometimes you can draw super fast!

But then the sparks require attention

Let your impressions inspire you!

If you let the feelings behind what you're drawing come through—"Cute!" "Cool!" or "Yummy!"—you will see the difference.

By doing so, your drawings will reflect your unique vision.

Try to pay attention to your impressions as you are drawing.

Let the colors inspire you!

Different colors convey different ideas—"Fun!" "Kind" or "Cold!"—and you can use this to your advantage.

See the messages behind various colors, and imagine how they can help you to express your own feelings.

Kind

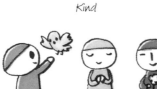

Cool

Energetic

Depressed

prologue

It was a warm and breezy afternoon,
and the twins Pen and Rayon had dozed
off to sleep while they were drawing.

Their dogs, Book and Marble, were
snuggled up next to each of them,
cozy in bed.

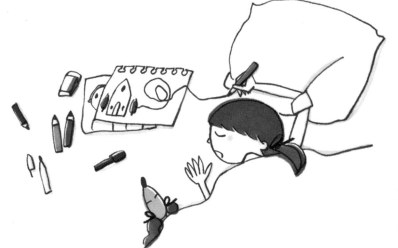

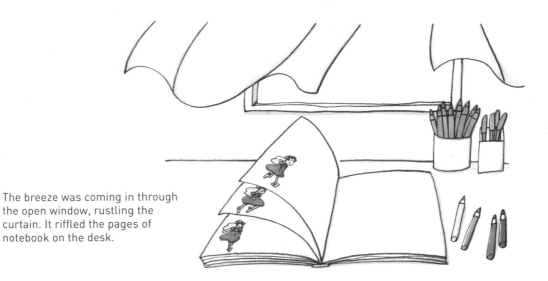

The breeze was coming in through the open window, rustling the curtain. It riffled the pages of notebook on the desk.

Oh, dear! Someone was running along the edge of the pages. As the pages turned, she seemed like she was getting closer and closer. Was this one of Pen's or Rayon's drawings?

It was a girl—she's barefoot and has a grass garland in her hair. Just as the pages flipped past, the girl leapt from the notebook.

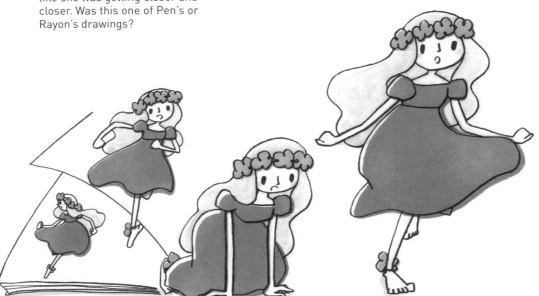

"Wake up, everyone!"

In a loud voice, the barefoot girl tried to rouse the sleeping twins.

"Hmm, what is it? Snack time?"

Rayon sat up, her eyes only half-open, and said, "Who's here?"

Pen grabbed his glasses by his pillow and put them on.

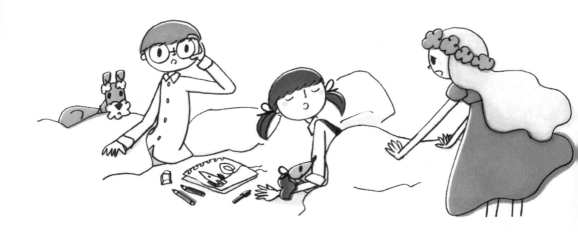

Choose a name
you like for her
✓

The girl loudly introduced herself, "I'm _____ from Sing and Dance Island!"

"Everyone on my island has been erased... There's no one left...

The 'Eraserheads' just erased them all. You're both good at drawing, aren't you?

You've got to redraw our world!"

"Eraserheads?"

The always-meek Pen replied. "What a scary name... I-I'm sorry but, I don't think we can help you..."

Book was also trembling with fear.

"Miss _____, where is your island?" Rayon asked more kindly.

"Right here!" the girl said, opening the notebook.

The notebook loomed larger and larger, and a strange gloom crept out from the open pages.

They heard an eerie sound coming from the gloom.

"Bwa-ha-ha... Hey, you spoiled-brat doodlers! Ho-ho-ho... Do you think you have the powers of creativity?"

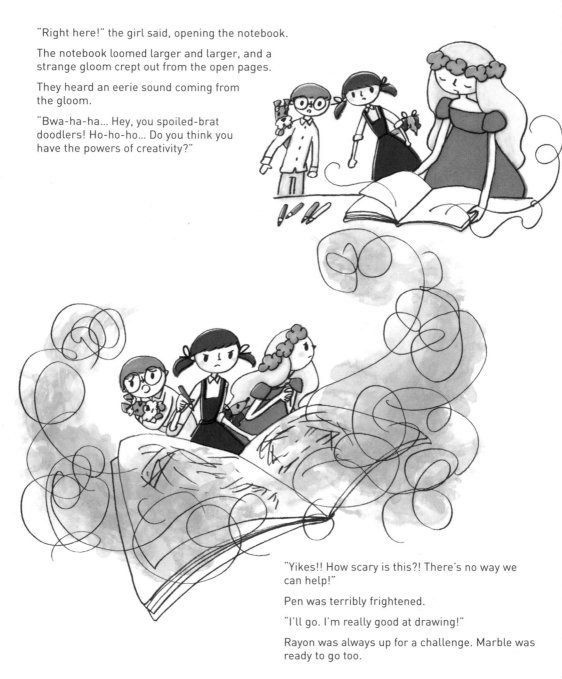

"Yikes!! How scary is this?! There's no way we can help!"

Pen was terribly frightened.

"I'll go. I'm really good at drawing!"

Rayon was always up for a challenge. Marble was ready to go too.

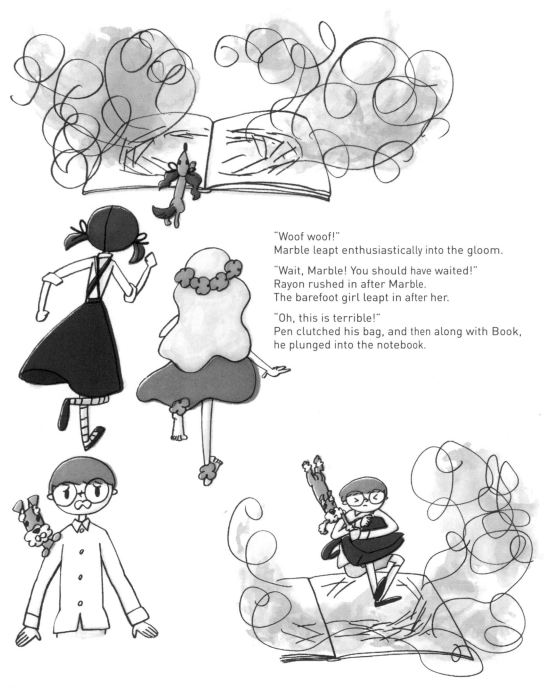

"Woof woof!"
Marble leapt enthusiastically into the gloom.

"Wait, Marble! You should have waited!"
Rayon rushed in after Marble.
The barefoot girl leapt in after her.

"Oh, this is terrible!"
Pen clutched his bag, and then along with Book,
he plunged into the notebook.

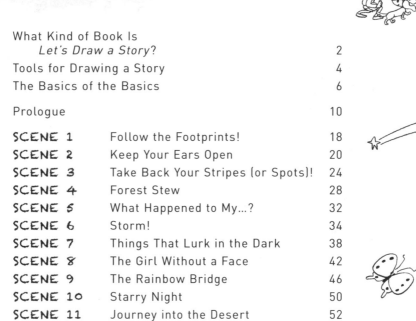

CONTENTS

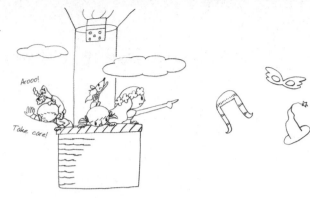

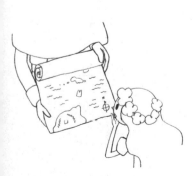

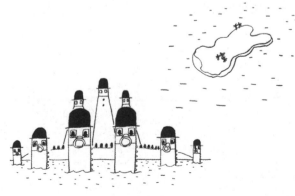

SCENE 1
Follow the Footprints!

"Where did everybody go?"- Fog billowed all around, as far as Pen could see. It seemed like the others had left him behind.

"Wh-What should I do...? I'm scared..."

"Pen! Take a look at this—woof!"

"Yikes! Wh-Who said that?"

"It's me—woof!"
His dog Book called out from Pen's side.

"B-Book?! ...How is it that you can talk?"

"It's just that, in this world, you can understand what I'm saying... But look—aren't these the others' footprints? We've got to hurry after them—woof!"

"You're right! We should follow them. But the fog is so scary..."

SMALL HINT!

Which footprints are whose?

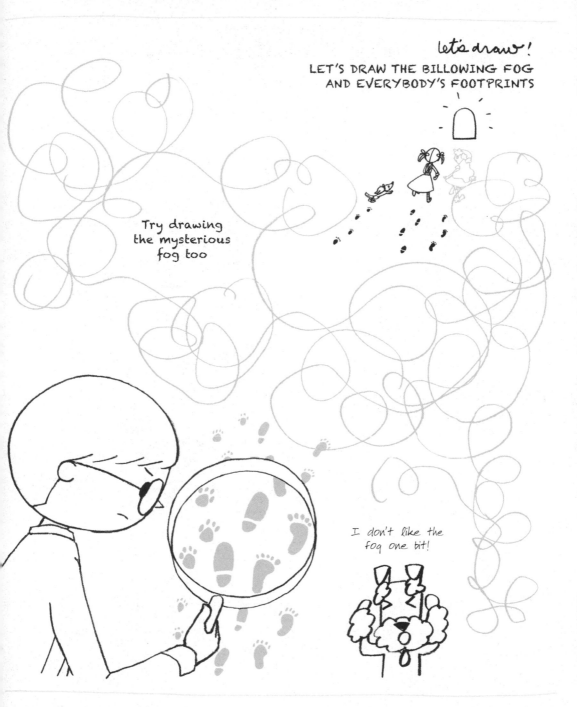

let's draw!

LET'S DRAW THE BILLOWING FOG
AND EVERYBODY'S FOOTPRINTS

Try drawing
the mysterious
fog too

I don't like the
fog one bit!

Keep Your Ears Open

"Hey everybody, wait for me!"

"Pen! You're here!"

The twins and the two dogs were used to always being together.

In the distance they could hear various calls and cries.

"Howl" "Roarrr"

"Cock-a-doodle-doo" "Cheep-cheep"

"Meow meow" "Squeak squeak"

"Hoot hoot"

"We've been erased by the Eraserheads!" "Can you draw us again?"

"Hey, I hear something," _____ said, as she listened carefully.

"Yikes!! I'm scared!"
Pen began to tremble with fear.

"Your voice might be scary too, Pen. Don't frighten the others!"

Rayon took out her pencil.

"Pen, aren't there animals drawn in your notebook?"

"Of course there are!" Pen looked up, proudly showing her the pages.

SMALL HINT!

How to draw a wolf

First draw the forehead and chin

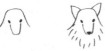

Add thick fur

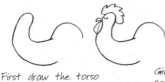

And a strong body

Sturdy legs and a fine coat make him look good

Don't let the dogs get too close

How to draw a lion

First draw the forehead and chin

The eyes and mane bring out his ferocity

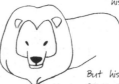

But his ears and paws are round like a feline

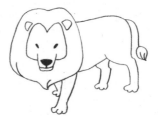

How to draw a rooster

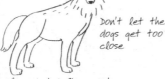

First draw the torso

Give him powerful feet

The direction of his feathers is important

How to draw a chick

First draw a snowman

Then add eyes, a beak, and tiny feet

How to draw an owl

First draw the division between the head and the belly

Then draw around its face

How to draw a mouse

Draw the eyes on the front part

The paws are small but the toes are long

How to draw a cat

Draw the cat's back

Phew! Eureka!

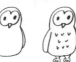

The upright tail gives it balance

This makes it look like she's standing on the tiptoes of all her paws

The thighs disappear

let's draw!

LET'S DRAW THE ANIMALS WITH THE SOUNDS THEY MAKE

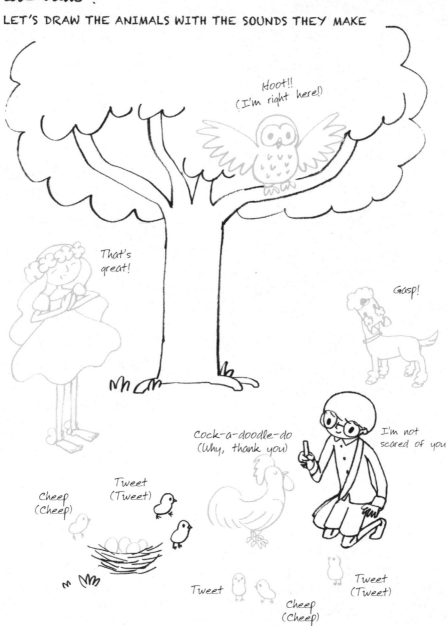

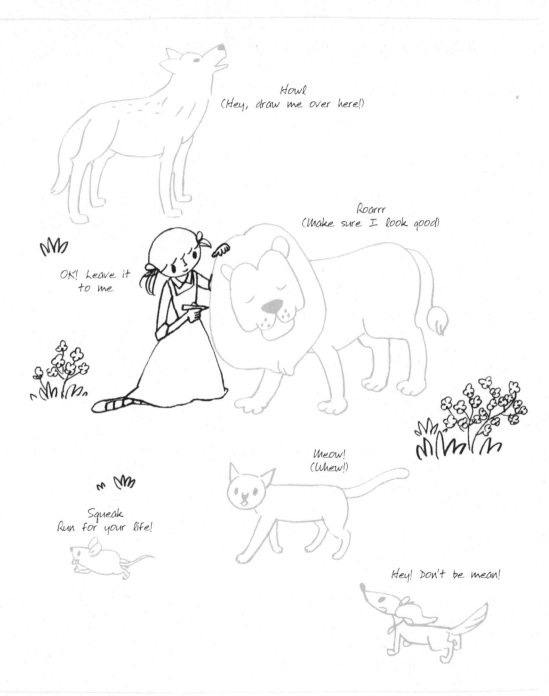

Take Back Your Stripes (or Spots)!

"Ahem, excuse me. Could we ask for a favor?"

They turned to see the animals that had gathered before them.

"You all haven't been erased."

"No, but you're not supposed to be plain white, are you? Your patterns have been erased, haven't they?

"That's right. And our patterns were pretty fantastic!"

The panda bear that now looked like a polar bear started to cry.

"Psst..."

A small voice spoke up from below.

"We look like we've changed our patterns too..."

A little snake whispered.

"Me too, I'm actually..."

A butterfly said, and fluttered off.

"I understand. We'll redraw your fantastic stripes and spots!"

Cow spots

Spotted patches

ANIMAL PATTERNS ARE FASCINATING!

SUPPOSEDLY THEY PROTECT THEM FROM PREDATORS,

BUT I'M NOT SO SURE...

Leopard spots

Zebra stripes

The pattern branches off around the haunches

Flower pattern

Polka dots

Stars

Checks

Stripes

Hearts

let's draw!

LET'S GIVE THE ANIMALS BACK THEIR PATTERNS

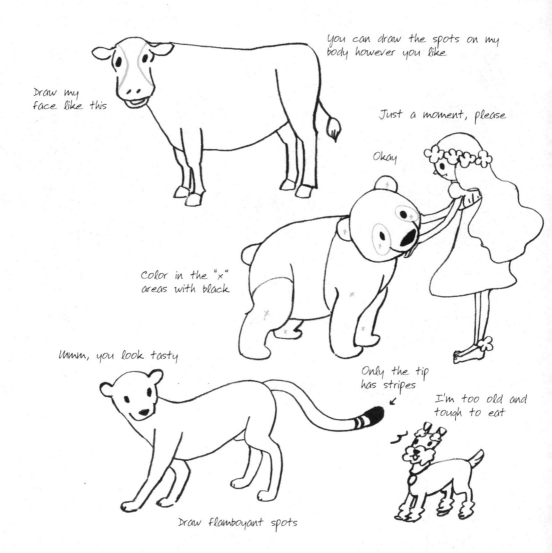

You can draw the spots on my body however you like

Draw my face like this

Just a moment, please

Okay

Color in the "x" areas with black

Ummm, you look tasty

Only the tip has stripes

I'm too old and tough to eat

Draw flamboyant spots

I'm not a horse, I'm a zebra

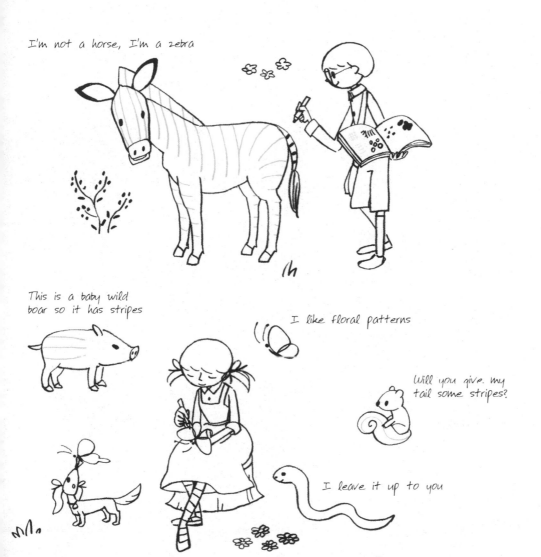

This is a baby wild
boar so it has stripes

I like floral patterns

Will you give my
tail some stripes?

I leave it up to you

SCENE 4
Forest Stew

Pen, Rayon, and the others made their way into the forest. "I'm hungry, Pen. I could really go for some of Mom's stew!"

"Mmm. With a big glass of milk!" Pen's stomach rumbled loudly.

"Rayon, why don't you draw a pot?!"

As Rayon started drawing a huge cauldron, _____ began to sing in a surprisingly loud voice.

A great big pot of stew ♫

Everyone in the forest, come and get it ♪

Let's all eat together ♫

A heaping pot of vegetable stew ♪

As the huge pot that Rayon drew appeared before them in the forest, the animals heard the song and brought ingredients for the stew.

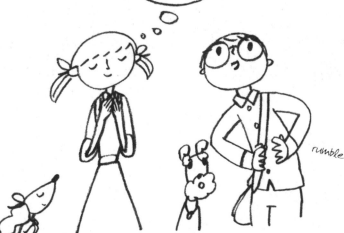

rumble

SMALL HINT!

How to draw potatoes

 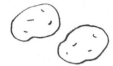

Draw an irregular round shape

Add a bumpy surface

How to draw carrots

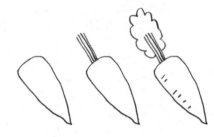

How to draw mushrooms

Draw the edge of the cap

Add the stem

How to draw broccoli

First draw the shaggy part of the floret

Then add the stalk

How to draw fish

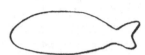

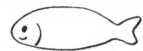

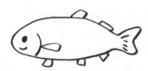

Fish have lots of fins

How to draw sausages

Draw as many links as you like

let's draw!

LET'S DRAW THE INGREDIENTS FOR A DELICIOUS STEW

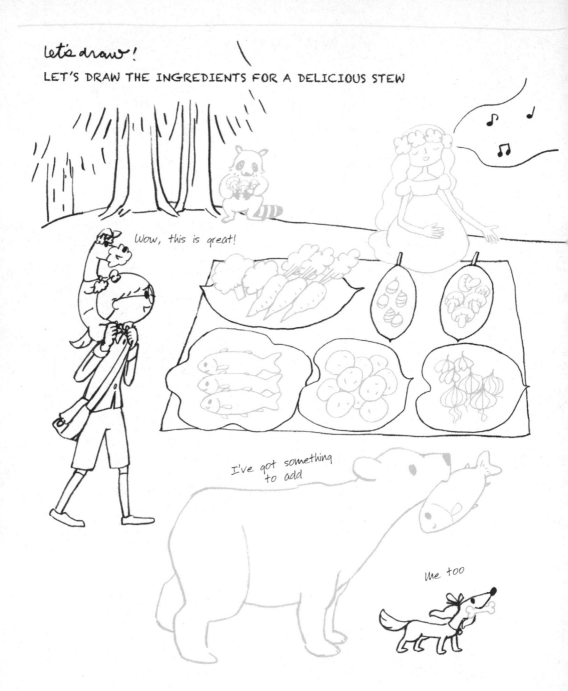

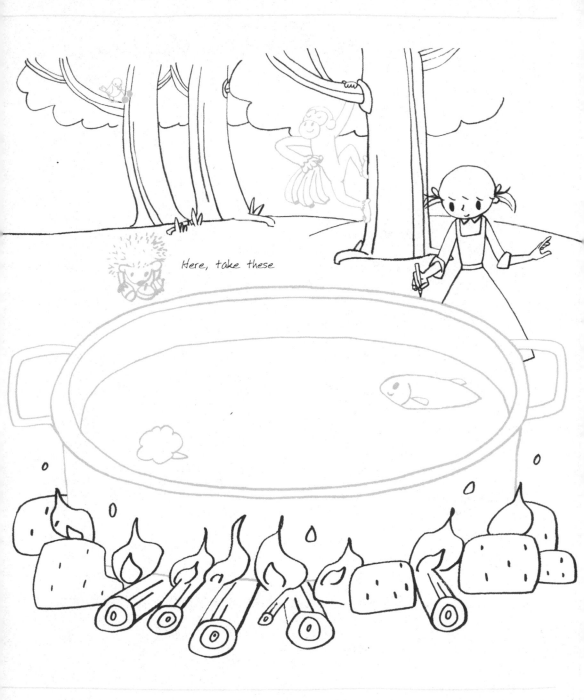

What Happened to My...?

"Oh, no! It looks like the parts you're so proud of have been erased!"

"Over there!"

_____ pointed to where a meadow spread out before them.

There were a number of large animals bickering over something.

"Listen! My trunk is really long, right?"

"My neck is really long!"

"So is mine."

"I've got a pretty long tongue."

"All of me is long."

I'm long too!

Hey now!

SMALL HINT!

Let's have a look at these animals' special features

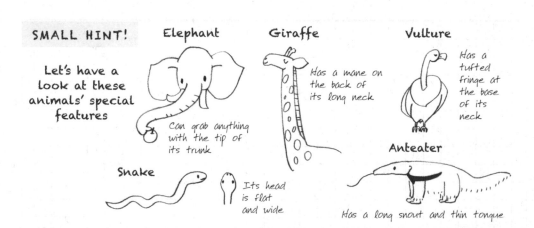

Elephant — Can grab anything with the tip of its trunk

Giraffe — Has a mane on the back of its long neck

Vulture — Has a tufted fringe at the base of its neck

Anteater — Has a long snout and thin tongue

Snake — Its head is flat and wide

LET'S DRAW THE LONG PARTS OF THESE ANIMALS

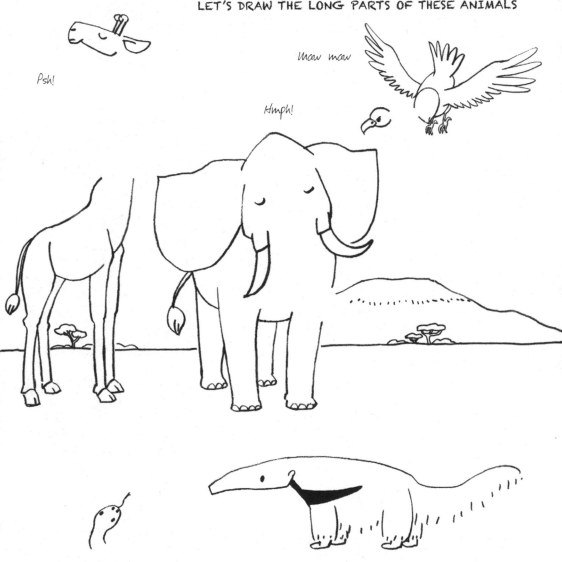

Psh!

maw maw

Hmph!

You've got a pretty long body too

And your tongue is pretty long too

SCENE 6
Storm!

As they emerged onto a plain, suddenly the sky grew dark.

Whoosh whoosh whoosh

Crash!

Rumblerumblerumble!

Ssssssss!

"Yikes!! I'm scared! Is that thunder?"

"It's cold! Is that rain?"

"I don't see anything, but it seems like a storm..."

"Huh? You mean even the weather was erased?!

That's incredible!"

"All right, then, I guess we'll have to draw it."

"Don't forget to draw an umbrella, so you won't get wet!"

It's cold!

...but nothing's there

What are the different kinds of rain?

Big raindrops Drizzle

Let's draw lightning

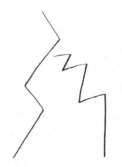 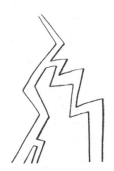

Draw jagged, gradually widening lines

Make double, connected lines

Let's draw the spray that splashes up

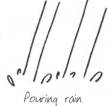

Pouring rain

What about the wind?

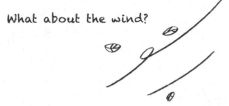

Since you can't see the wind, a good way to show it is by drawing things that are blown about or fluttering around

Let's think about ways to keep from getting wet

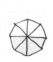

Umbrellas usually have eight ribs

This is the part you can see

Umbrellas made of leaves

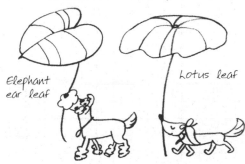

Elephant ear leaf

Lotus leaf

let's draw!

RAYON IS CRAZY ABOUT DRAWING STORMS

Pen found a mountain cliff and started drawing a cave where he could take shelter from the storm.

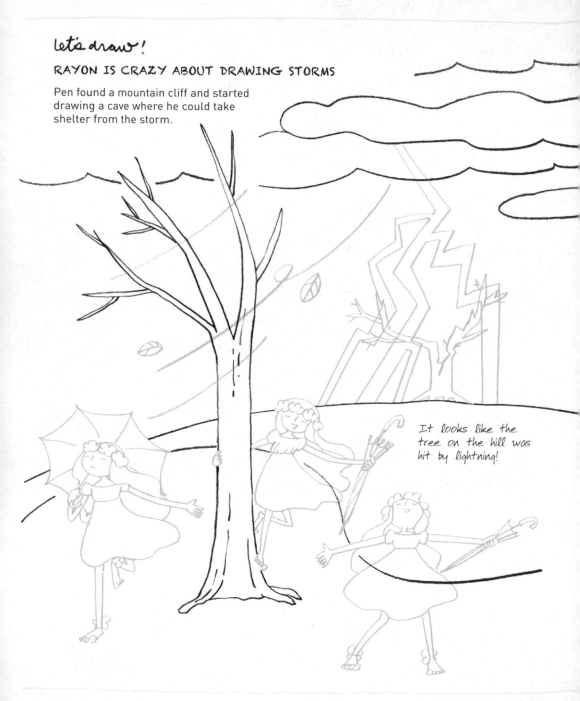

It looks like the tree on the hill was hit by lightning!

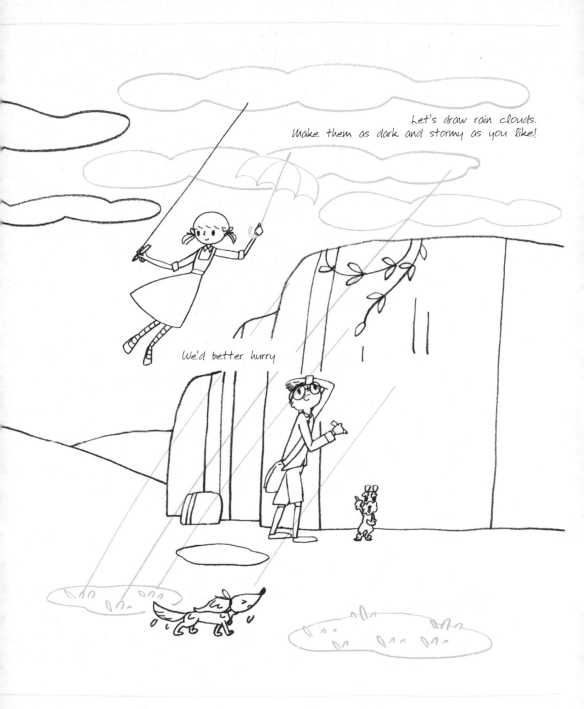

SCENE 7
Things That Lurk in the Dark

The cave went deep inside the mountain.

It was pitch black inside—they couldn't see anything.

"Pen, what's in there?" Rayon asked.

"I have no idea. I just drew the entrance to it..."

"I'll go and see!" Their dog Marble ran all the way into the cave.

"Marble! You shouldn't go in there by yourself!" Rayon called after her.

"I'm worried about Marble. We should go in there too—woof!" Book said.

"I-I'm just going to wait here, okay?" Pen said.

"Everyone, come quickly! There's a girl crying!"

Marble's voice echoed loudly from deep within the cave.

SMALL HINT!

LET'S TRY DRAWING SCARY GHOSTS AND NOT-SO-SCARY GHOSTS

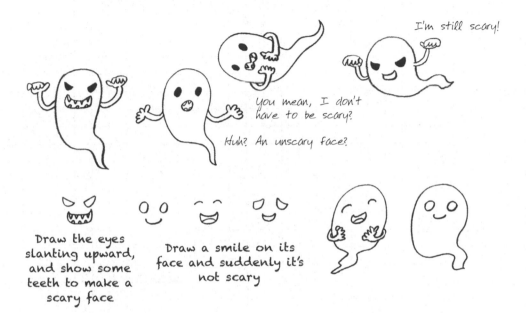

I'm still scary!

You mean, I don't have to be scary?

Huh? An unscary face?

Draw the eyes slanting upward, and show some teeth to make a scary face

Draw a smile on its face and suddenly it's not scary

How to draw a bat

They look cute with round ears and a pig nose

Actually, there are five ribs in their wings

Color-in to make a silhouette

How to draw a gecko

Face

Draw the body and tail clearly

They have five fingers on each foot

The forelegs face forward

The hind legs face backward

let's draw!

LET'S TRY DRAWING SCARY GHOSTS AND NOT-SO-SCARY GHOSTS
THERE MIGHT BE BATS AND GECKOS IN THE DARK TOO

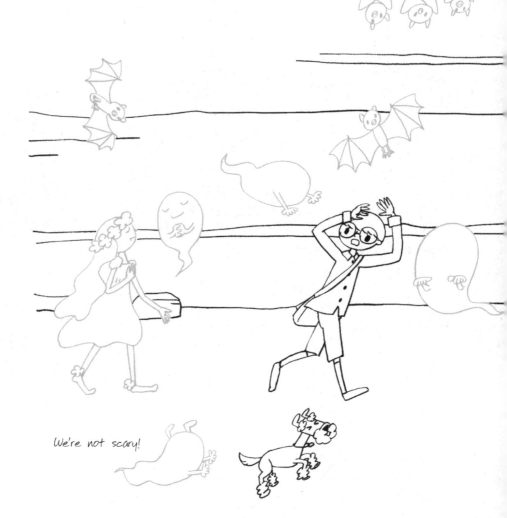

We're not scary!

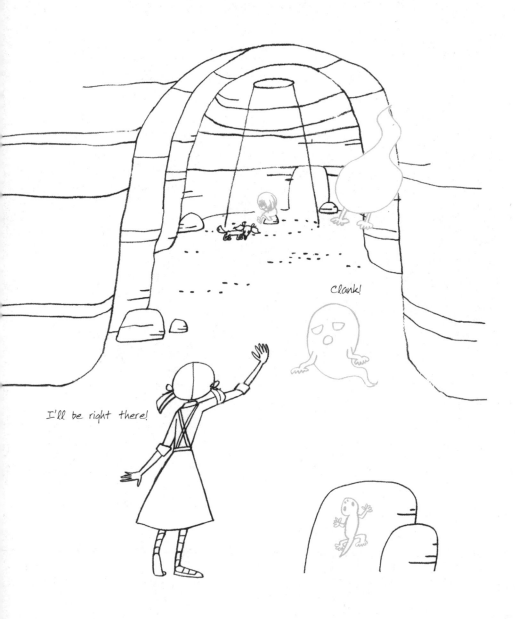

The Girl Without a Face

Deep within the cave, there was a girl crying.

"Hiccup... Give it back..."

"What happened to you? Why are you crying?"

"Hiccup... They erased my face!"

The girl looked up, and her eyes, nose, and mouth were all gone.

"Yikes!" "Eek!"

Pen was a scaredy-cat, so it was no surprise that he was spooked, but this time even Rayon let out a little shriek.

"I'm sorry if I scared all of you."

"...It's okay. Leave this to me. I'll draw your face and make you yourself again."

"You will, really? Thank you!" the girl replied.

"No fair to do just her! Me too!"

"Me too!" "Me first!"

From further inside the cave, a chorus of children's voices cried out.

LET'S DRAW VARIOUS FACIAL EXPRESSIONS

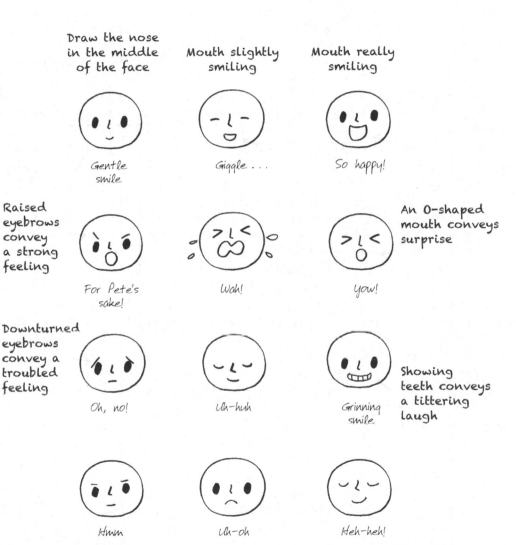

Draw the nose
in the middle
of the face

Gentle
smile

Mouth slightly
smiling

Giggle . . .

Mouth really
smiling

So happy!

Raised
eyebrows
convey
a strong
feeling

For Pete's
sake!

Wah!

An O-shaped
mouth conveys
surprise

Yow!

Downturned
eyebrows
convey a
troubled
feeling

Oh, no!

Uh-huh

Grinning
smile

Showing
teeth conveys
a tittering
laugh

Hmm

Uh-oh

Heh-heh!

let's draw!

"This child cries all the time.

This child is a little grumpy.

This child is a shy little thing.

Always crying Smiling

This child is easygoing.

And me, I'm always smiling."

Easygoing

Everyone gets their turn

Grumpy

Shy

SCENE 9
The Rainbow Bridge

Once the children got their faces back, they felt like themselves again.

"The Eraserheads kidnapped us and erased our faces..."

"I couldn't believe our faces were gone, and then it seemed like we fell from over there."

"This is terrible! I want to go home now!"

There were several holes in the ceiling of the cave.

"But how are we going to climb up there?" Pen asked worriedly.

"I'll draw a ladder!" Rayon said enthusiastically.

"A staircase will work too." "We could draw a rope." "Or a trampoline!"

Everyone came up with lots of good ideas.

While they were talking excitedly, a beautiful rainbow appeared in the sky above.

"That's it! How about if we get there on a rainbow bridge?"

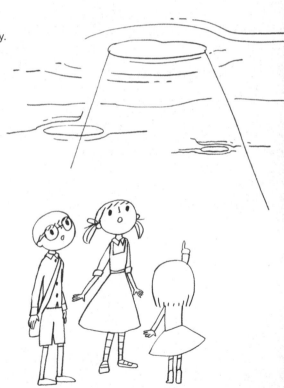

Staircase

Ladder

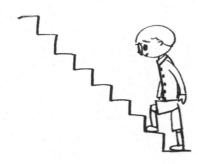

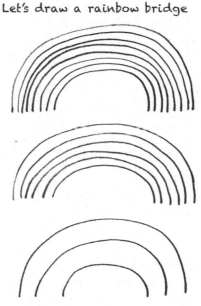

Make each rung correspond to the width of a footstep

What are other ways to go?

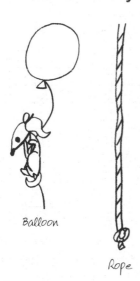

Balloon

Rope

Let's draw a rainbow bridge

Rainbows can be made up of seven colors, five colors, or even just two colors. Let's try coloring it in with whatever colors you like.

let's draw!

THERE ARE MANY WAYS TO GET ABOVE GROUND FROM THE CAVE

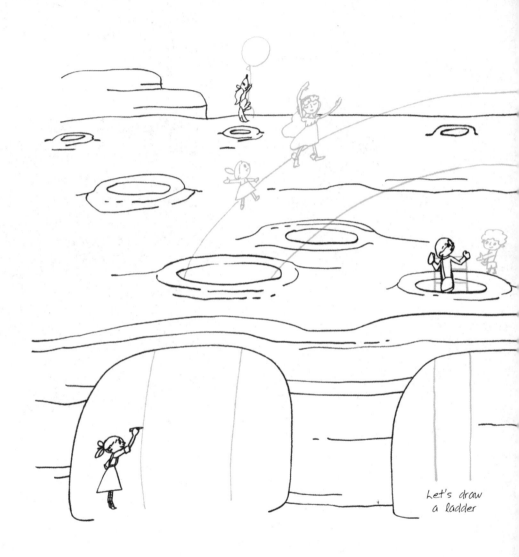

Let's draw
a ladder

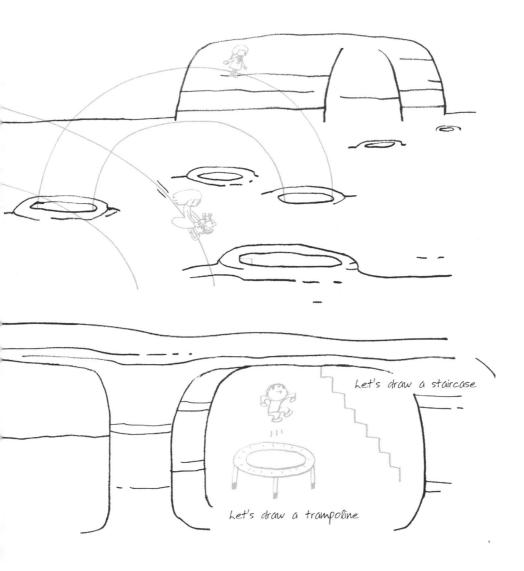

Let's draw a staircase

Let's draw a trampoline

SCENE 10
Starry Night

"We did it!" "We made it out!" "Feels good to be outside!"

While everyone was busy celebrating, night fell.

"Wait a minute... something's not right here. The sun's gone, but there's no moon or stars!"

"Leave it to me! Pen, tell me where the stars should go."

Rayon drew a big moon and started drawing lots of stars.

"It's time for the moon and the stars to come out—woof! The sun sleeps while we're sleeping too—woof!"

Book called out to everyone happily.

SMALL HINT!

Let's draw stars

Star Twinkling
 star

o

Tiny star

Let's draw a shooting star

Draw the trail

Let's draw the moon

Draw craters

Full moon Half-moon Crescent moon

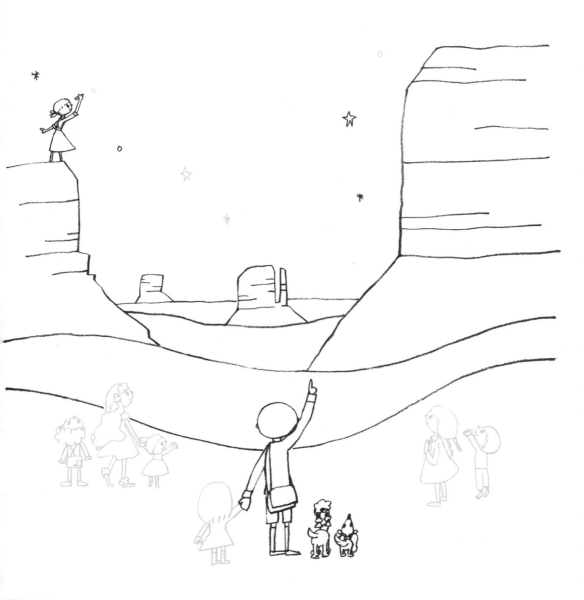

SCENE 11
Journey into the Desert

W-Water

"Give me water! Please!"

"Me too!"

"Again? But you just drank some!"

Rayon kept having to draw glasses of water for everyone.

"There's no use just constantly drawing water. Let's think this through!"

Pen called out to everyone.

"How about cloaks to protect us from the sun?"

"I'd like a tent where we could rest!"

After they crossed over the plain, a beautiful desert spread out before them.

But a journey into the desert is no simple thing.

You can walk for hours, and the sand dunes just go on and on.

SMALL HINT!

Let's draw a palm tree

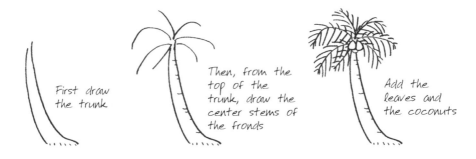

First draw the trunk

Then, from the top of the trunk, draw the center stems of the fronds

Add the leaves and the coconuts

First, draw the head, then the ear, eye, and nose

Let's draw a camel

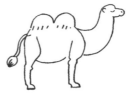

Draw a large, curved neck

Then draw the humps and the belly

Add legs and a tail

Let's investigate shadows

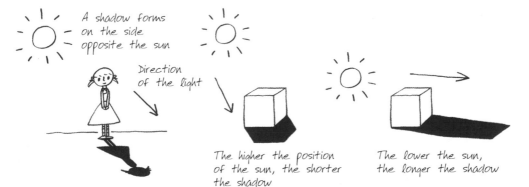

A shadow forms on the side opposite the sun

Direction of the light

The higher the position of the sun, the shorter the shadow

The lower the sun, the longer the shadow

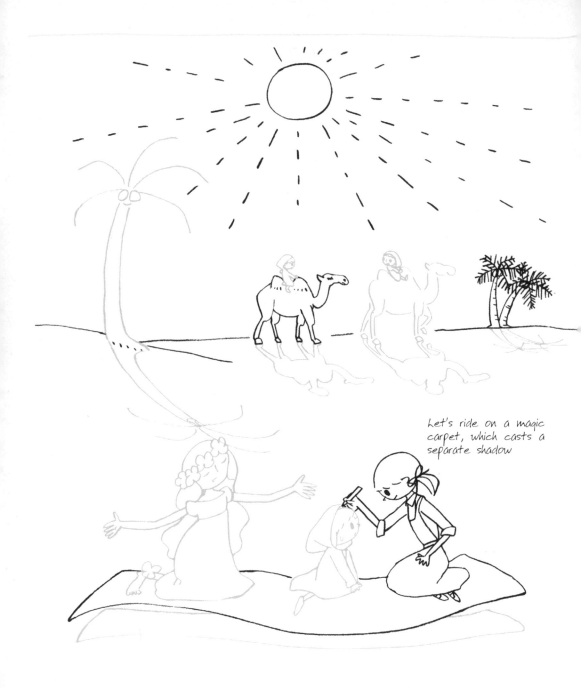

Let's ride on a magic carpet, which casts a separate shadow

WHAT KINDS OF THINGS ARE USEFUL TO
HAVE FOR A JOURNEY INTO THE DESERT?

LET'S TRY TO THINK ABOUT WHAT KINDS OF SHADOWS
ARE FORMED, BASED ON THE POSITION OF THE SUN

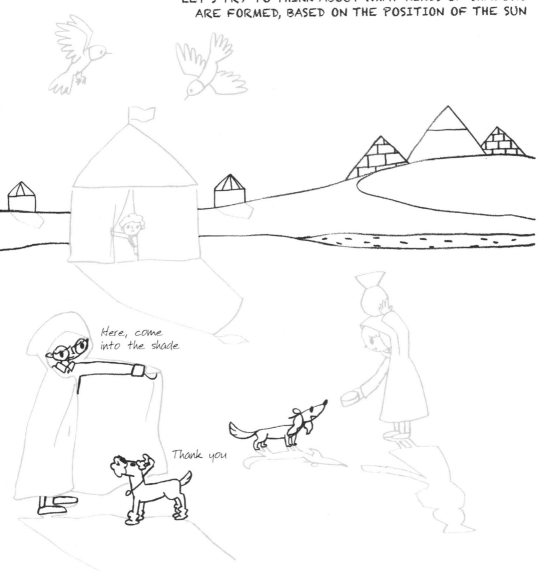

Here, come
into the shade

Thank you

The Missing Village

"You can see our village from that hill."

One of the children said as they dashed up the slope.

"Oh, no!" "Huh?" "Where'd the village go?"

All they could see was a big gaping blank space.

The only thing left was a road that stretched out in the middle of it.

"Are you sure this is the right spot?"

"Definitely—this big tree is our landmark!"

"They must have erased the village too."

"Incredible...!"

The children all started to cry.

"It'll be alright. We're here with you. Tell us what your village was like."

"It's not lost. Just try to remember the details of your village."

Rayon and Pen were confident they could help.

SMALL HINT!

What kind of houses?

Three-story

Two-story

Let's draw roofs

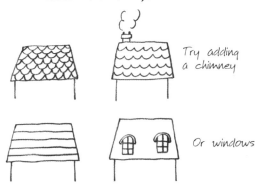

Try adding a chimney

Or windows

Let's draw windows

Try decorating them with flowers

For small windows, you can just draw a silhouette

Let's draw balconies

Let's draw doors

Double doors

Try adding a doorstep

Single doors

let's draw!

TRY DRAWING THE BUILDINGS IN THE VILLAGE

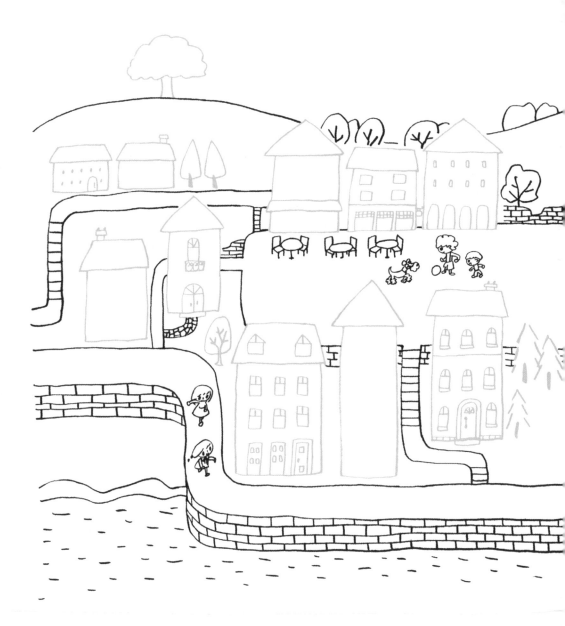

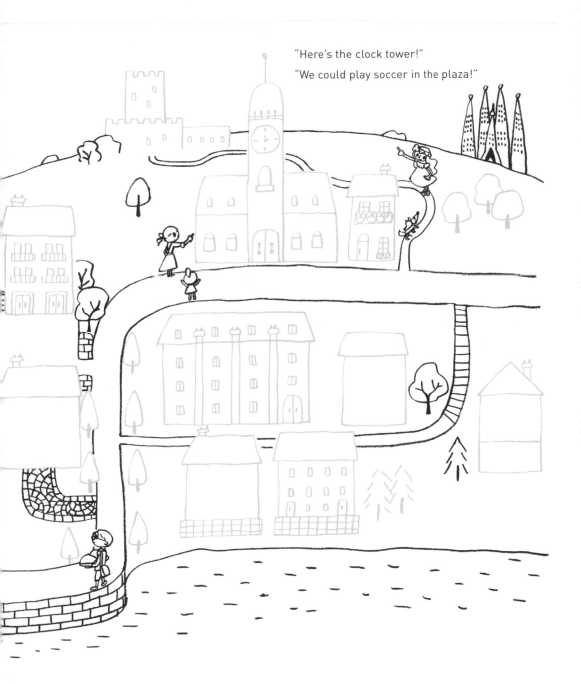

"Here's the clock tower!"

"We could play soccer in the plaza!"

SCENE 13
Decorate Your Room

Once they restored the village, the children returned to each of their own homes.

But they all soon came running back out of their houses.

"This is terrible! The house is completely empty!"

"Well, well—we'll just have to put everything back, won't we?"

With his notebook in hand, Pen began to ask each of them what they remembered about their rooms.

"My bed was soft and fluffy."

"There were dolls and blocks, and let's see, what else..."

"I had a radio that my father gave me!"

"I had so many books, but I can't remember them all..."

"And there were pictures on the wall!"

"I've got it. Leave it to me!"

Rayon was impatient to get started on redrawing everyone's rooms.

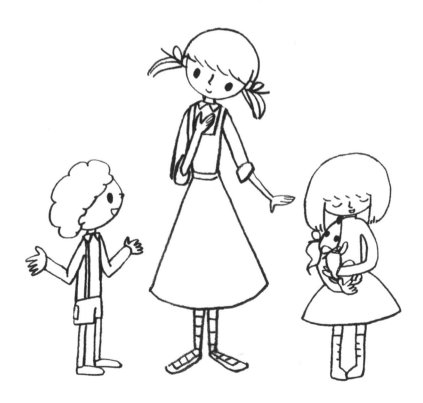

SMALL HINT!

What to hang on the wall?

A garland or banner

Famous paintings

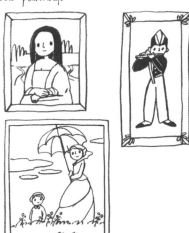

What kind of light?

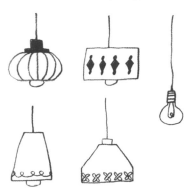

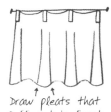

Let's draw curtains

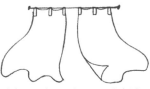

Draw pleats that puff out in front

When they flutter lightly

Try adding folds

Let's draw a radio

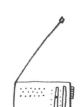

Let's draw a bed

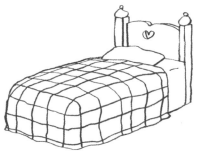

Show how soft it is by making the pattern follow the contours of the bed

let's draw!

TRY DRAWING THIS ROOM

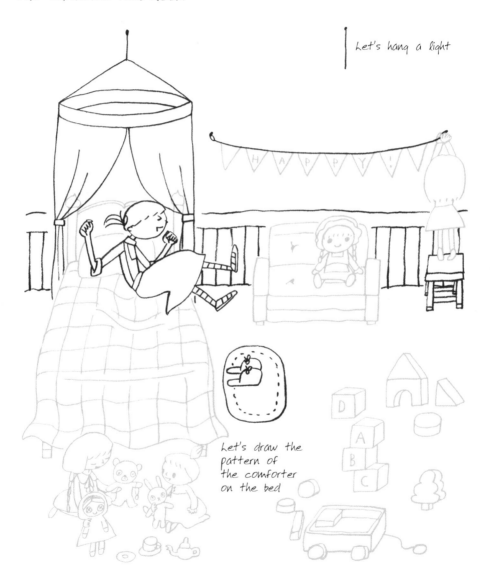

Let's hang a light

Let's draw the pattern of the comforter on the bed

Let's draw the pictures
inside the frames

Let's draw curtains
fluttering in the breeze

Choose your favorite book
titles for the spines

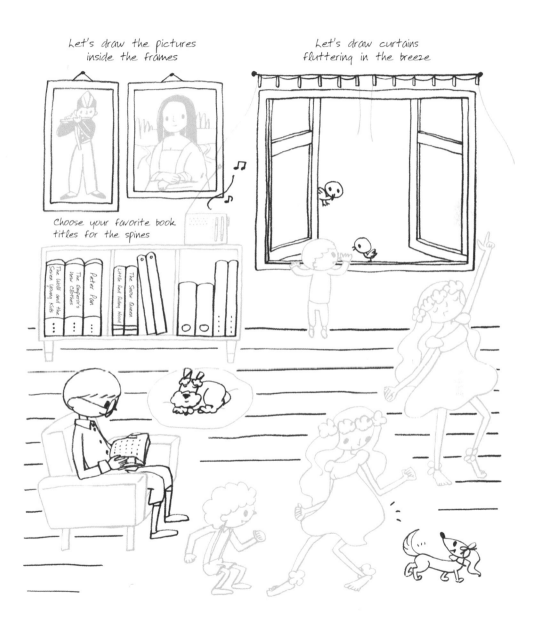

The Wolf and the Seven Young Kids

The Emperor's New Clothes

Peter Pan

The Snow Queen

Little Red Riding Hood

The People Who Live in the Village

The children's rooms were back to the way they were, but there was still no liveliness in the village.

And no wonder, since the people in the village had been erased too.

"I miss my mom," a boy said sadly.

"Next we'll draw everyone's family and the village's people!"

Rayon said, reaching up on her tiptoes to draw a round head.

"Were there a lot of people other than your family living here?"

"Draw the lady who bakes the cakes. I want to eat cake!"

"I have a cavity that's bothering me... I need to go see the dentist!"

"I miss the old lady who lives in my neighborhood!"

"My mother and I have exactly the same hairstyle."

"My father wears smart-looking suits."

The children all called out the details about their parents.

SMALL HINT!

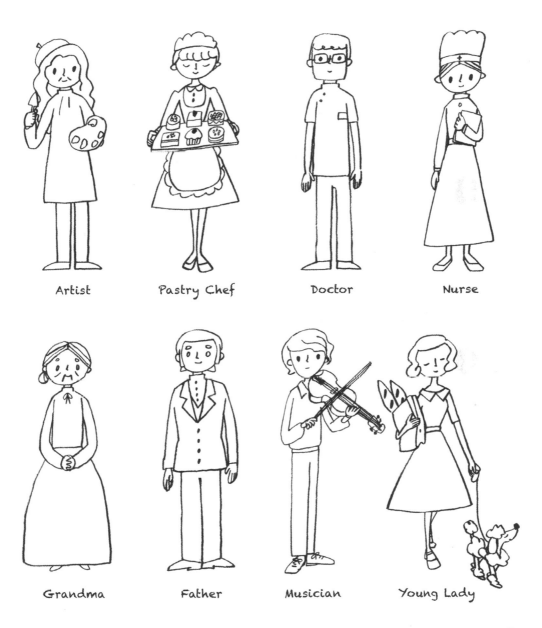

Artist Pastry Chef Doctor Nurse

Grandma Father Musician Young Lady

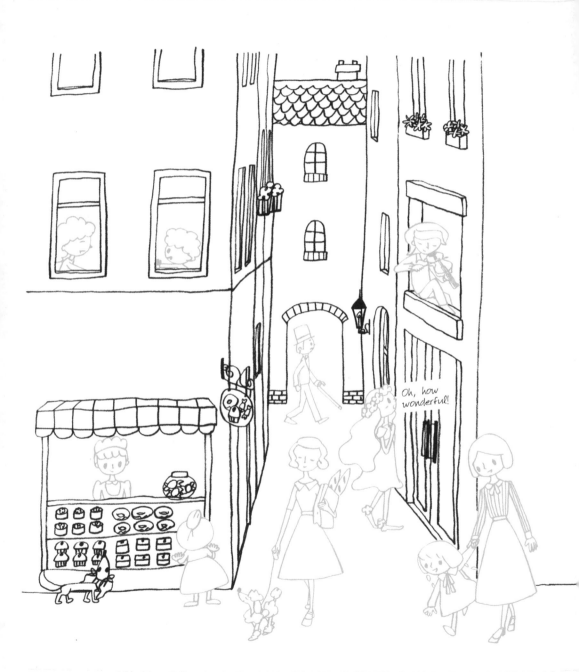

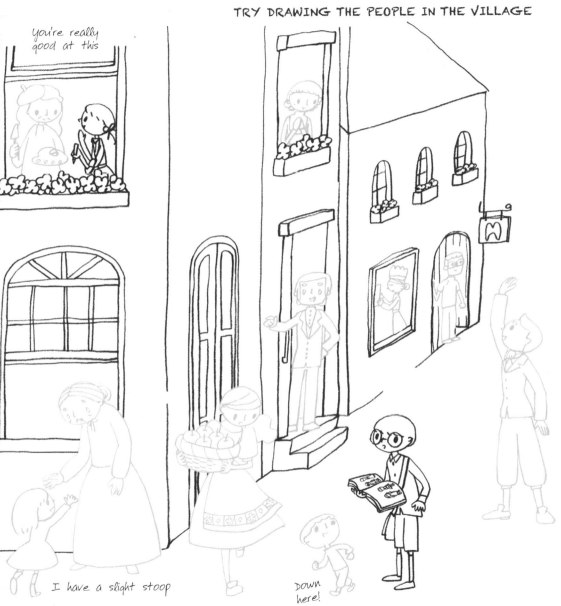

Breaktime!

First draw a circle

Then draw his face and bangs. He and Rayon look exactly alike!

Draw the outline of his hair, just a little bigger than his head, then add his glasses

Decide on the length of his shirt and his pants

Then draw his hands, arms, legs, and feet, add his bag, and he's finished!

Side

Back

Look! It's written right here

I'm scared... wobble

All right, I'm leaving!

RAYON

First draw a circle

Then draw her face and bangs.

Draw the outline of her hair, just a little bigger than her head

Tie up her hair on both sides

Find a balance between the size of her torso and the length of her skirt

Draw her hands, arms, legs, and feet, her clothes, give her a pencil, and she's finished!

Side

Back

Leave it to me!

Shh! I'm right at a good point!

Love you!

69

GIRL

First draw a circle

Then draw her face and, where her bangs are, draw a grass garland

Draw the outline of her hair, just a little bigger than her head

Draw an airy and light dress with an empire waist

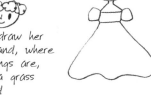

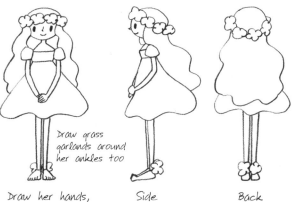

Draw grass garlands around her ankles too

Draw her hands, arms, legs, and bare feet, draw her long hair, and she's finished!

Side

Back

Hula dance

La-la-la [musical note]

Ballet

BOOK

First draw his
fluffy beard

Then draw his eyes,
nose, and eyebrows

Make his face square
and his ears triangular

Draw his neck
and body

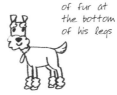
Draw his legs,
feet, and tail,
and he's finished!

Add tufts
of fur at
the bottom
of his legs

I'm sitting, just
like a good boy

Eek! You
startled me!

Zzzz...

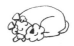

MARBLE

First draw her
face, tapering off
toward her nose

Then draw her
long, curly ears,
and add ribbons

Draw her
long torso

Then draw her short
little legs and feet,
and a long tail, and
she's finished!

Look at me, just
sitting here

Woof woof

Gotta run!

SCENE 15
Welcome to the Castle

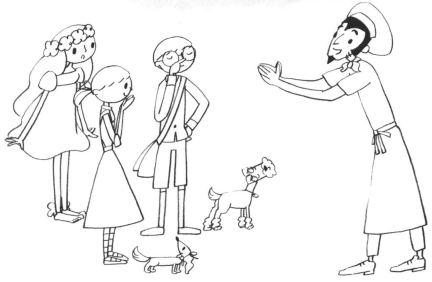

"Bravo! What wonderful drawings you do!"

A young man called out to Pen and Rayon.

"Thank you. I guess it must be from drawing every day," Rayon said modestly.

"Heh-heh. There's nothing in the world that we can't draw!"

Pen, on the other hand, responded pertly.

"In that case, I wonder if I could ask a favor? The castle was also erased. Would you be able to restore it to the way it was?"

"A castle! You mean, draw something that big?!" Rayon said as her eyes popped.

"Rayon, don't you think we could do it?" Suddenly Pen looked worried.

"No, that's not it. I can't help but get excited about it! Tell me more about this castle!"

"I'm the castle's chef. If I close my eyes, I can remember everything about the castle!"

SMALL HINT!

Let's draw roofs

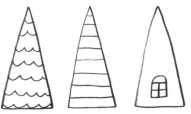

It looks marvelous
with windows

Let's draw the castle walls

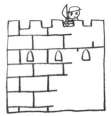

This is where they
shoot arrows from

Let's draw flags

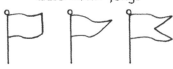

Let's draw the castle gate

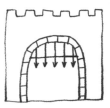

Let's draw the balcony

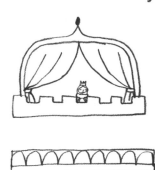

Let's draw brick walls

First draw horizontal lines

Then draw alternating
vertical lines

Draw vertical lines in
between as well, and
they're finished

let's draw!

"No, that's not it! The tower is over here! And it's higher!"

"That window over there, it shouldn't be square!"

"Would you be able to make my galley kitchen a little bigger?"

The young chef had many requests,

but try drawing the castle however you like.

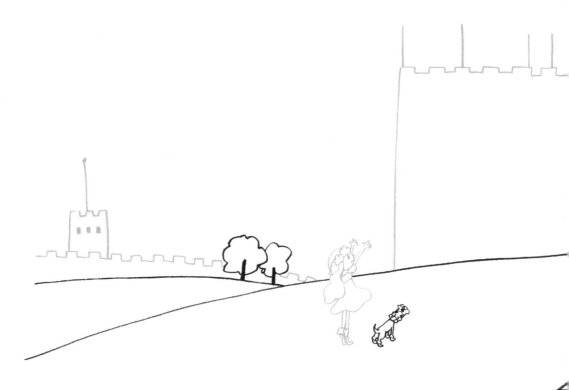

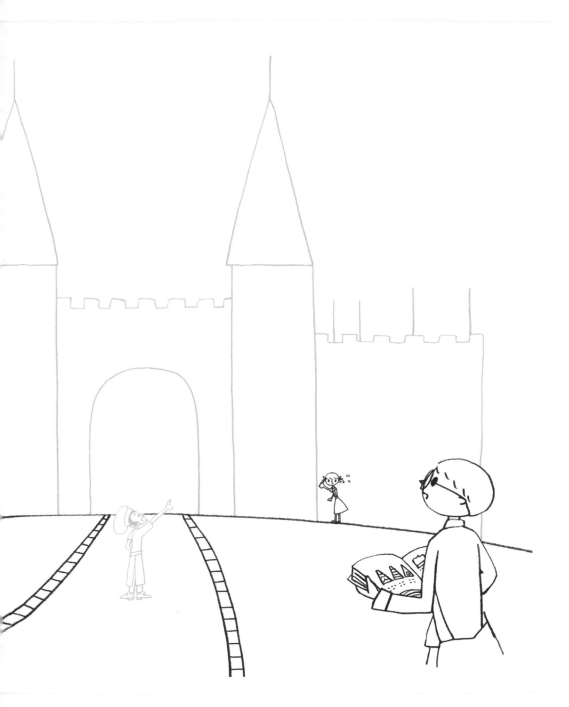

The King and the Queen

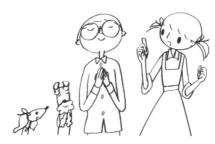

The young chef stood before the thrones of the king and the queen, speaking with his eyes closed.

"His Highness, the King, is gallant and very kind. He wears an elegant moustache, and has jet black waves of hair. His confident gaze and capable hands put everyone at ease."

"J-Just a moment—is this what you mean?"

Rayon felt the weight of her responsibility.

"The queen is indeed very beautiful, and her temperament is extremely pleasant. She smiles upon whomever she is speaking to. And, of course, the sparkling tiaras in her long lustrous hair suit her very well."

"I see, how marvelous. Rayon, hurry up and draw them!"

Pen was so excited, his face was bright red.

"Do you think the queen likes dogs?" Book asked, his tail going around in circles.

SMALL HINT!

Let's draw tiaras

Let's draw crowns

Let's add pretty hair ornaments

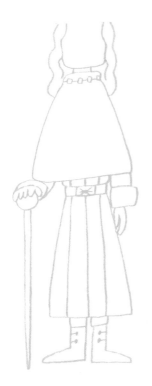

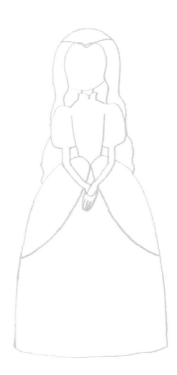

Let's draw fans

Let's draw various designs

Fleur-de-lis

Open palm

Leaf

Paired doves

Paisley

Dinnertime

The king and queen clasped each other's hands joyfully at being reunited.

Then they listened as the young chef recounted all that had happened.

"I hear that you have traveled far. I hope you will stay as long as you like. As a way of expressing our gratitude, would you be our guests for dinner?"

The queen extended her gracious invitation.

"Leave everything to me! I will begin preparing the food right away!"

The young chef's eyes were sparkling.

"I'll help you!"

_____ began to sing with gusto.

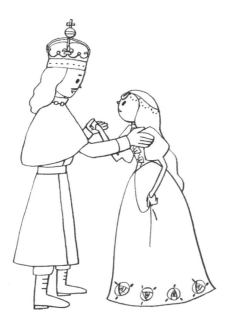

"Pen, Rayon, _____, and not to forget Book and Marble. The power of your imagination has restored this village. Please accept my deepest appreciation!"

The king looked each of them squarely in the eye as he spoke heartily.

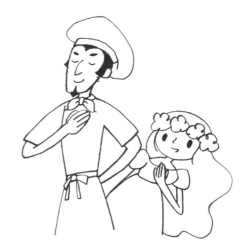

SMALL HINT!

Let's make pizza toppings

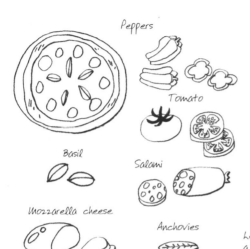

Peppers

Tomato

Basil

Salami

Mozzarella cheese

Anchovies

Let's draw bread

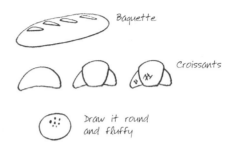

Baguette

Croissants

Draw it round and fluffy

Let's draw a steak

Char marks make it look delicious

Let's make it a thick cut

Let's draw a roasted turkey

First draw the large abdomen

Then draw the crossed legs

Make it lightly browned and tie up the drumsticks

Let's decorate cakes and cupcakes

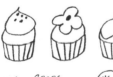

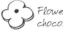 Cocoa powder

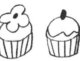 Silver Jordan almonds

Sugared violets

Whipped cream

Flower-shaped chocolate

Kiwi

Pineapple

Maraschino cherry

 Strawberry

Sparkler

Candle

 Strawberry

 Whipped cream

 Icing rose

79

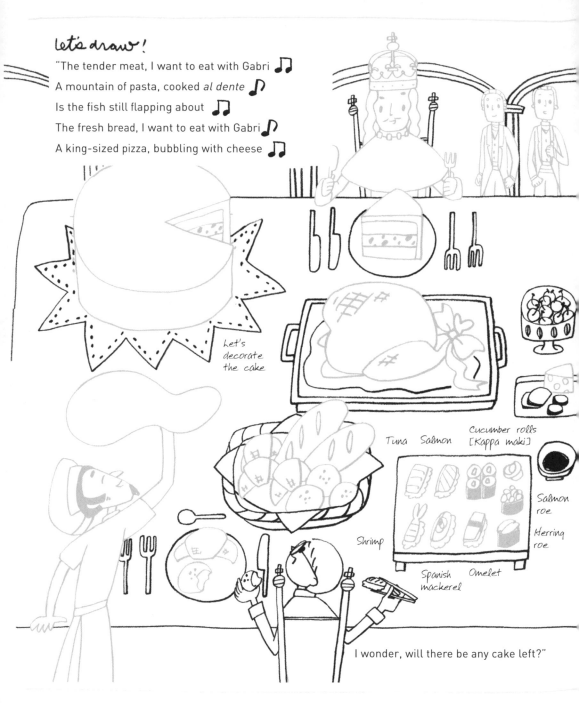

let's draw!

"The tender meat, I want to eat with Gabri ♫
A mountain of pasta, cooked *al dente* ♪
Is the fish still flapping about ♫
The fresh bread, I want to eat with Gabri ♪
A king-sized pizza, bubbling with cheese ♫

Let's decorate the cake

Tuna Salmon Cucumber rolls [Kappa maki]

Salmon roe

Herring roe

Shrimp

Spanish mackerel Omelet

I wonder, will there be any cake left?"

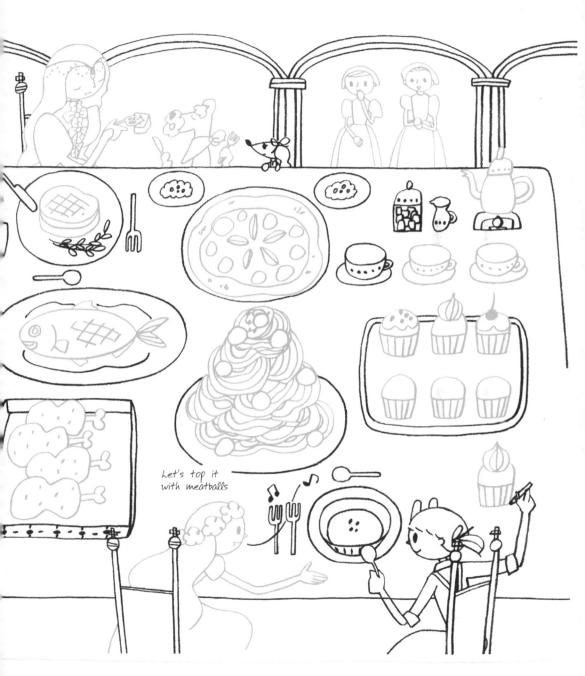

Let's top it
with meatballs

SCENE 18
Evil Shadows

As everyone was enjoying the dinner, large shadows appeared behind them.

"Give us some of that delicious feast!"

The large shadows seemed as though they were about to attack them all.

"Yikes!! I'm scared!"

Pen was already crouched over, but Rayon and the king were ready to bravely confront the shadows when, right at that moment,

Marble cried out from below,

"Everybody, relax!"

"You all are actually really small, aren't you?!"

SMALL HINT!

You can make giant shadows by shining a light against the wall or the ground.

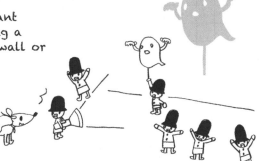

let's draw!

LET'S TRY DRAWING SHADOWS
REFLECTED ON THE WALL

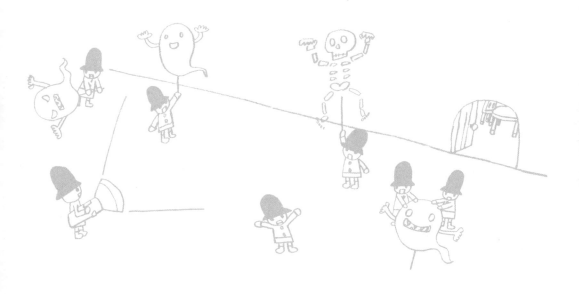

Taking Off in a Hot Air Balloon!

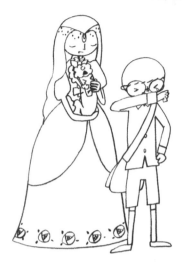

Once again, it was time for them to depart.

"I wish you all a safe journey!" The queen said.

Book seemed heartbroken to say goodbye to the queen.

"_____, take this with you. It's a map of your island."

The king handed it to her.

"Well, let's be on our way!"

Everyone piled into the hot air balloon that the king had prepared for their journey.

SMALL HINT!

Let's draw fun patterns using the seams of the hot air balloon

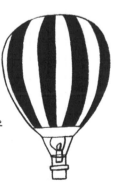
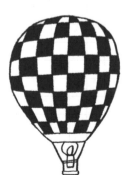
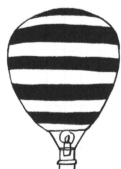

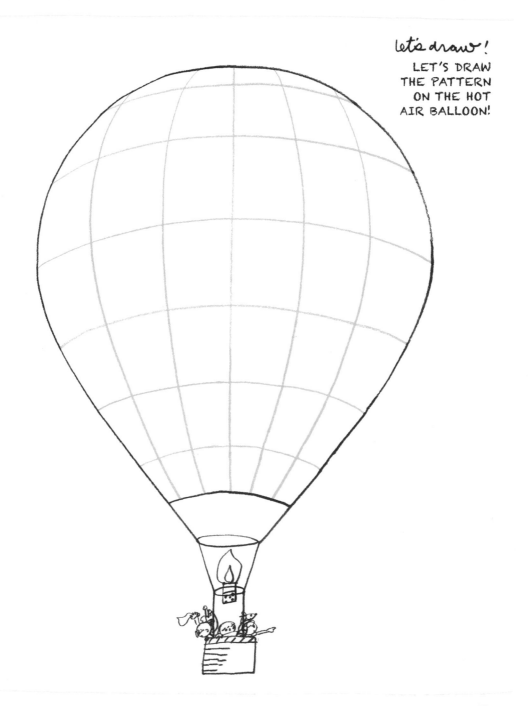

let's draw!

LET'S DRAW
THE PATTERN
ON THE HOT
AIR BALLOON!

Scenery Seen from the Sky

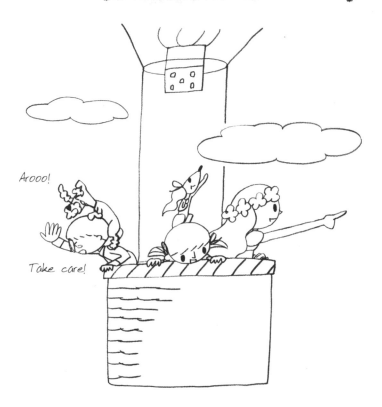

Arooo!

Take care!

The hot air balloon soared steadily higher in the sky.

The castle receded into the distance.

"Take good care!"

Pen and Book waved goodbye with tears in their eyes.

"Look how small the town looks!"

"Like a toy town..."

Small roads. Small houses. Small people moving about. Seen from faraway, the village scenery looked like a miniature garden.

"Hey, I want to eat a cloud!"

Marble was excited by how close they were to the clouds.

"Look over there! Now you can see the ocean!"

_____ said, pointing to the sea in the distance.

SMALL HINT!

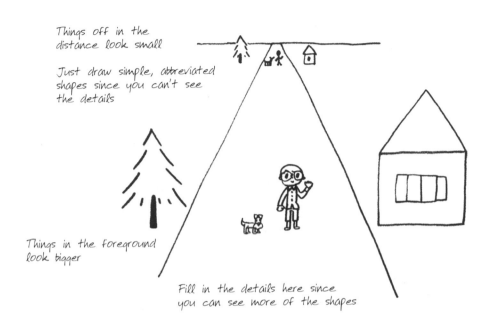

Things off in the distance look small

Just draw simple, abbreviated shapes since you can't see the details

Things in the foreground look bigger

Fill in the details here since you can see more of the shapes

Let's draw things in smaller, abbreviated form

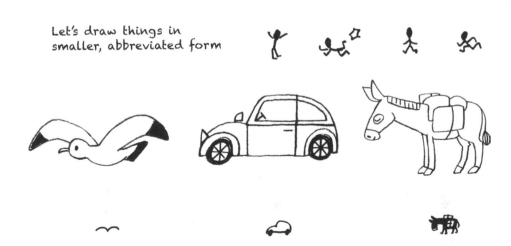

let's draw!

LET'S TRY DRAWING SCENERY SEEN FROM THE SKY

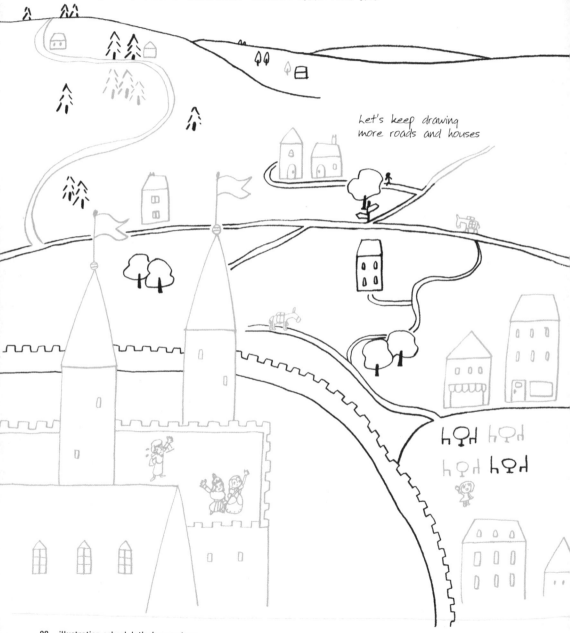

Let's keep drawing more roads and houses

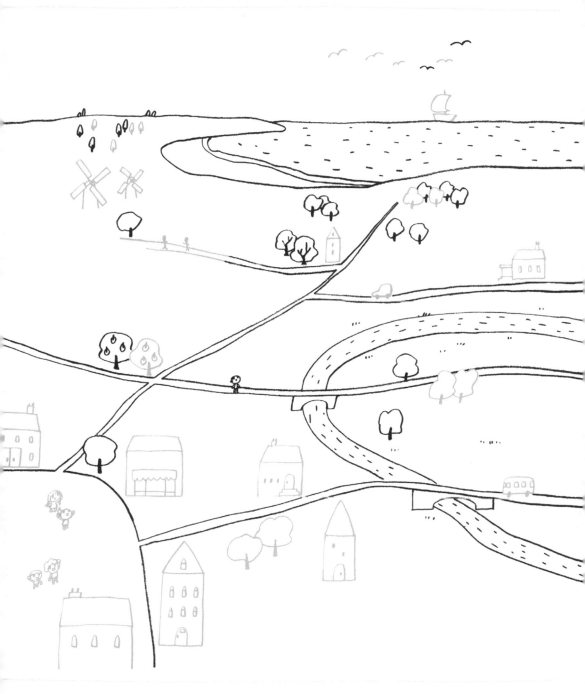

SCENE 21
Rabbit Island

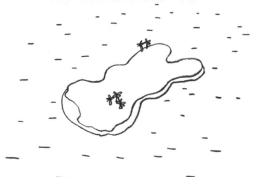

Far off in the ocean they could see Rabbit Island.

"There are lots of rabbits living on the island. They grow carrots and clover together. And I think they throw a lot of tea parties in their free time."

_____ informed them.

"I'd like to have tea with the rabbits,"

Rayon said excitedly.

"I don't really like carrots..."

Pen frowned.

When they arrived on Rabbit Island, one of the rabbits ran up to them and waved hello.

"Where are all the other rabbits—woof?" Book asked, noticing something awry.

They looked around, but still didn't see any other rabbits.

"They were all erased! All the rabbits who plow the fields with me, now they're gone!?

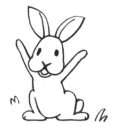

SMALL HINT!

Let's draw rabbits

Let's draw them in various poses

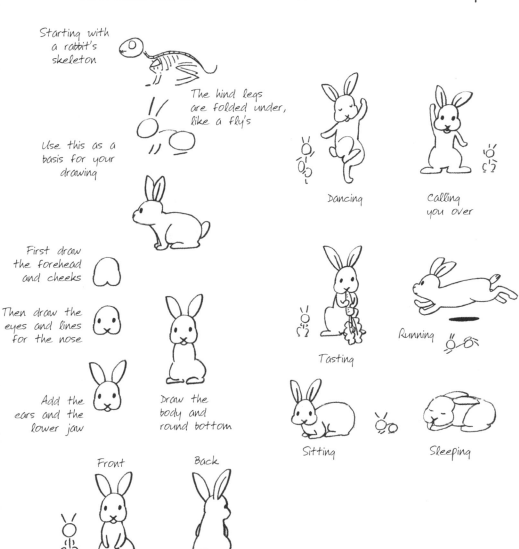

Starting with a rabbit's skeleton

The hind legs are folded under, like a fly's

Use this as a basis for your drawing

First draw the forehead and cheeks

Then draw the eyes and lines for the nose

Add the ears and the lower jaw

Draw the body and round bottom

Front

Back

Draw the little paws and you're done!

Dancing

Calling you over

Tasting

Running

Sitting

Sleeping

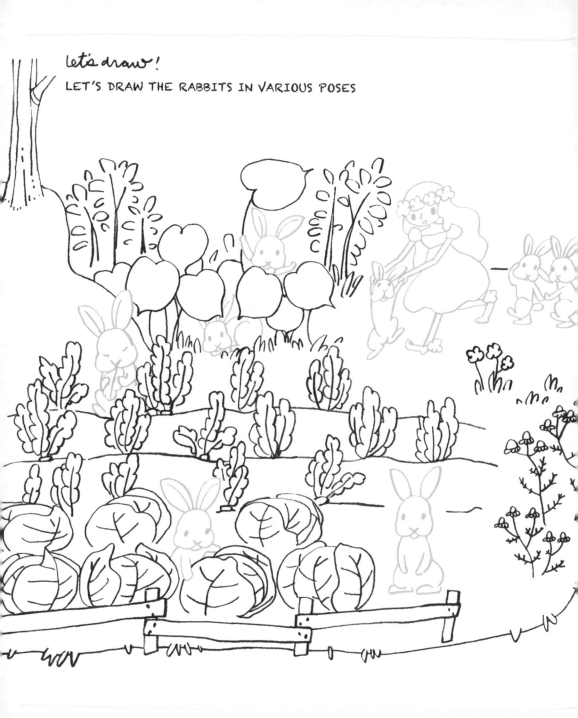

let's draw!

LET'S DRAW THE RABBITS IN VARIOUS POSES

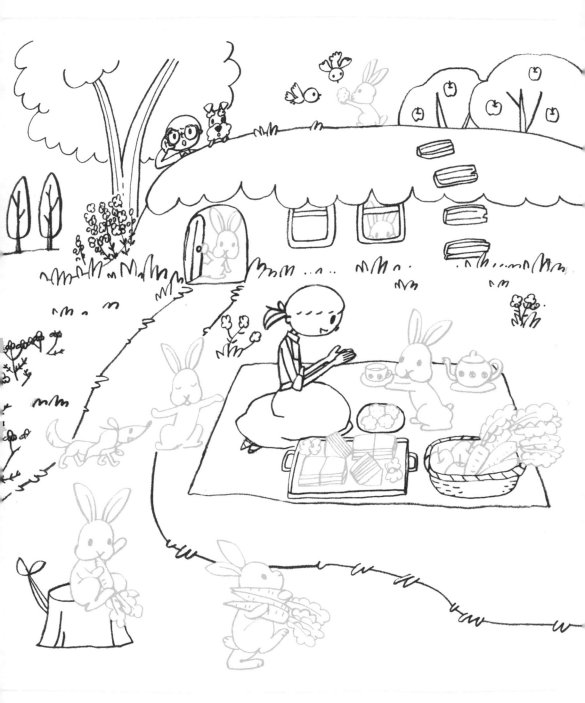

SCENE 22
Monster Island

Next to Rabbit Island, there was an island in the shape of a monster.

"Don't tell me... Is that by any chance...?" Pen asked.

"That's right. Monsters have lived there since long ago."

_____ informed them.

"Monsters?! You're serious?! I'm going home!"

Pen turned around and started walking in the other direction.

"Pen, look out!"

Pen slipped and almost fell off the cliff, but he was saved just in the nick of time by a monster.

The monster gently set Pen back on the ground and said,

"I'm sorry if I scared you. We only eat leaves, we don't eat humans. So there's nothing to be afraid of."

The monster looked sad.

"But I'm the only one left here. All the other were erased..."

"Don't worry. Leave it to us!"

Pen had already opened up his notebook to the page on monsters.

SMALL HINT!

Let's draw monsters

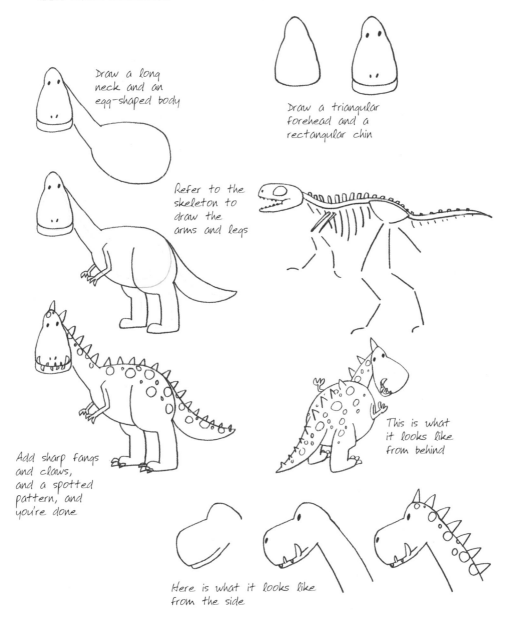

Draw a long neck and an egg-shaped body

Draw a triangular forehead and a rectangular chin

Refer to the skeleton to draw the arms and legs

Add sharp fangs and claws, and a spotted pattern, and you're done

This is what it looks like from behind

Here is what it looks like from the side

let's draw!

LET'S DRAW A BIG MONSTER, A MAMA MONSTER, AND BABY MONSTERS

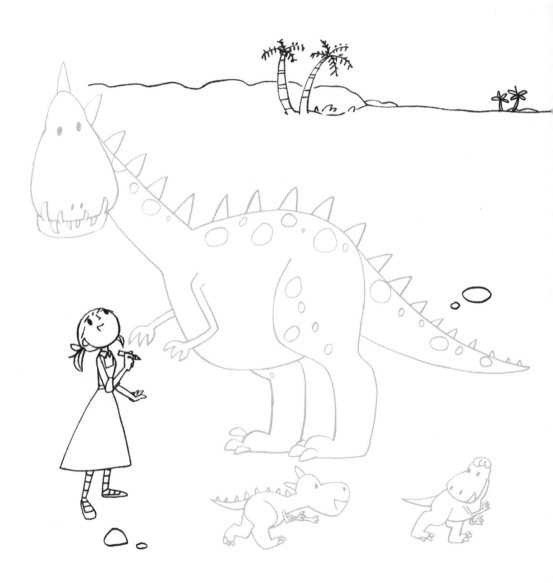

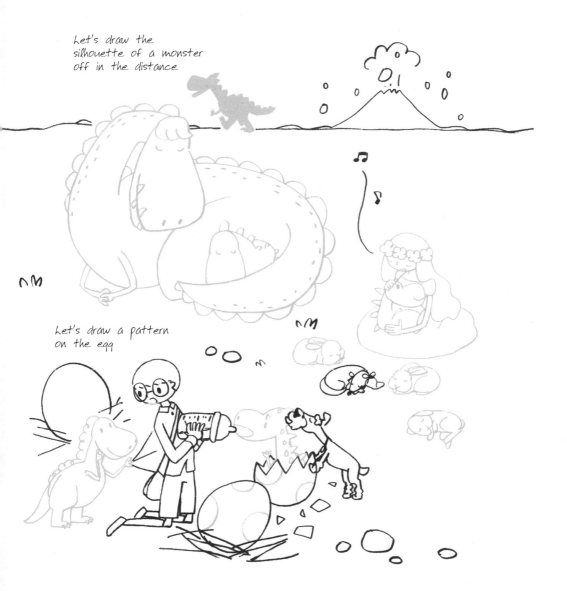

Let's draw the silhouette of a monster off in the distance

Let's draw a pattern on the egg

SCENE 23
Robot Island

With his long neck, the monster caught sight of the next island before anyone else. This island was very square.

"I wonder what island this is?"

"Such a square island looks pretty interesting—woof!"

Marble and Book were curious to find out.

When they descended on the island, the people were gathered around a box-shaped square, and they all looked upset for some reason.

"Our god has stopped moving..."

"He was amazing—every day he would predict tomorrow's weather!"

Pen reached out and touched the smooth surface of the box-shaped square and said,

"Is this, by any chance, a robot?"

The monster insisted on repaying the favor so he climbed aboard the cramped hot air balloon.

Wait a minute—at some point, the rabbits must have come along too...

SMALL HINT!

Let's draw the face of the robot

Sleeping

Awake

Thinking

let's draw!

Let's try drawing the face of the robot.

The robot might say something like,

"Tomorrow will be sunny. Wave height will be 20 inches (50 cm)."

you can do it!

Thank you, thank you

I'm so glad

SCENE 24
Sing and Dance Island

At the end of a very long journey, an exceptionally large island came into sight. However, they could not see anybody on the island. Everything was quiet and still.

"This island is my home. Here, songs and dances from all over the world come together. The music never stops playing, from morning until night. I'm finally back home. Even though I can't see or hear them, I have every reason to think they are still singing and dancing!"

Once they arrived on the island, _____ started singing various songs and dancing various dances.

"Wow, an island with songs and dances from all over the world! It must be fun all the time!" Rayon said.

"The moves look a little difficult but let's try them!"

Rayon and Book were excited to learn the dance moves.

"Please take me with you. Surely I will be of service," the robot said.

"But don't the people on the island need you?"

"They will be fine," the robot said, as something printed out from its back.

"Here is the weather forecast for the next month. I downloaded it."

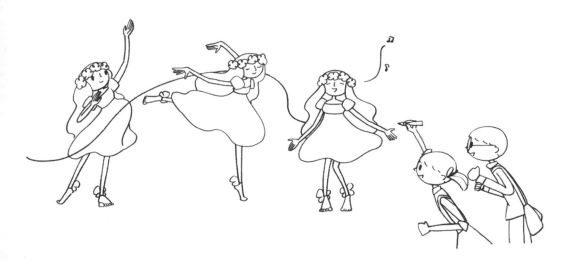

SMALL HINT!

LET'S DRAW PEOPLE DANCING

Use these skeletons as a basis for drawing people's bodies in different positions

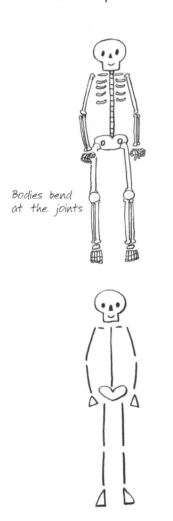

Bodies bend at the joints

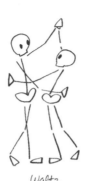

Waltz

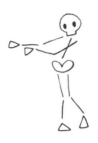

Hula dance

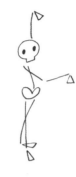

Flamenco

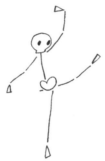

Ballet

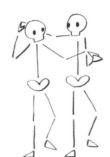

Folk dance

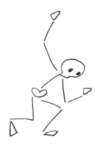

Rock and roll

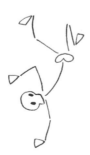

Breakdancing

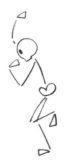

Awa [native] dance

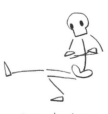

Cossack dance

let's draw!

EVERYONE IS SINGING AND DANCING IN THEIR FAVORITE WAY.

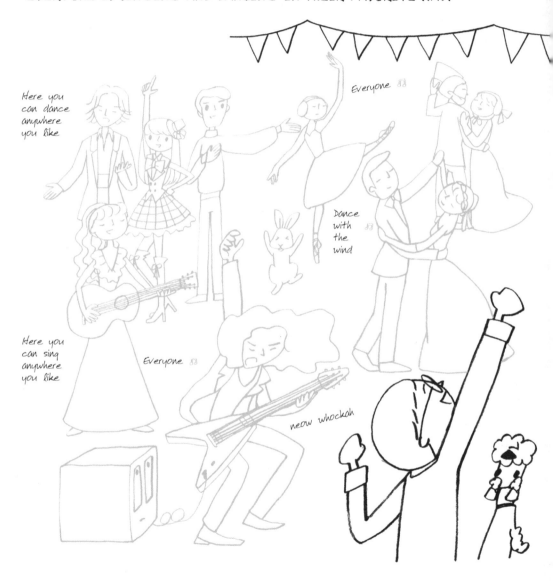

Here you can dance anywhere you like

Everyone

Dance with the wind

Here you can sing anywhere you like

Everyone

neow whockah

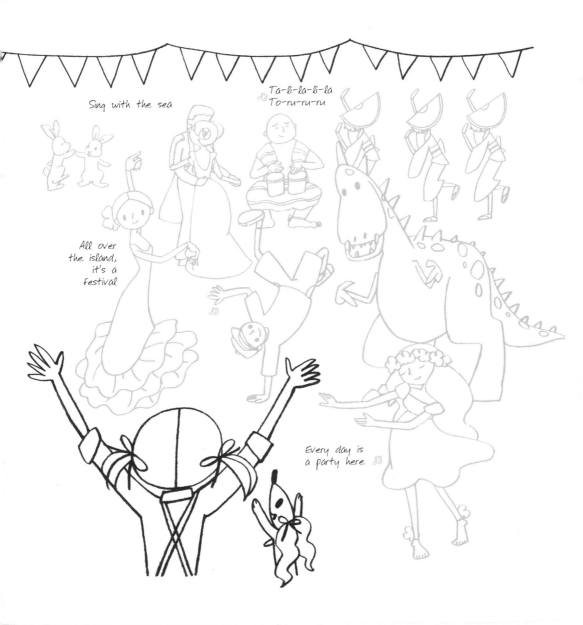

Sing with the sea

♪Ta-li-la-li-la
To-ru-ru-ru

All over
the island,
it's a
festival

Every day is
a party here ♫

Hoist the Sail!

They had reached the final battle. They were ready to set off for the fortress of the Eraserheads, who were going around erasing everything.

Everyone from the island came to see them off.

"You all be careful! They have put out wanted posters for you."

"That hot air balloon is too conspicuous. Take this sailboat instead."

"Those guys, they don't seem to like loud noises. That must be why they targeted this island first."

"If it looks like you're losing, just run away! You can always go back and fight again!"

"Leave this to us, everybody!"

"I feel seasick... ugh!" Pen said.

"Are you alright? I'm a robot so I don't get seasick..."

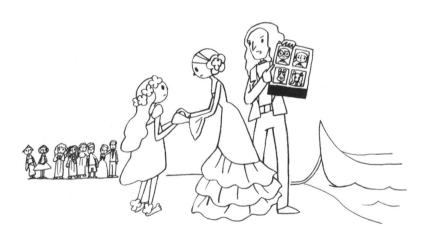

SMALL HINT! Flags and sails stream and billow in the opposite direction from where the wind is blowing

let's draw!

LET'S DRAW THE BOAT AND THE SAIL BILLOWING IN THE WIND

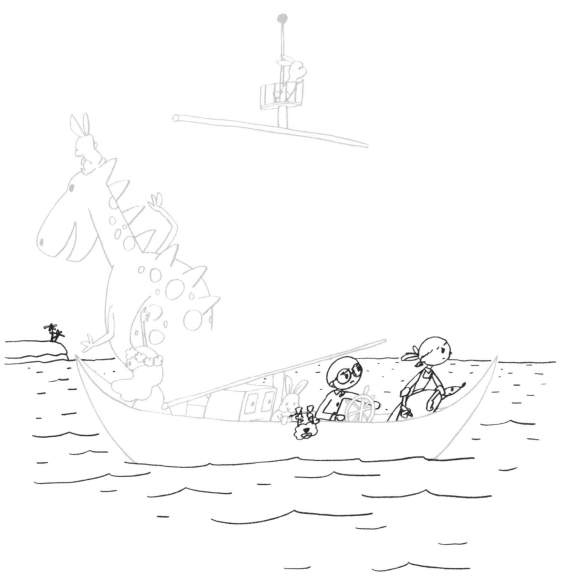

A Disguise Contest

The Eraserheads' fort appeared from behind a mysterious fog. As they neared the shore, they could see there were many guards all around.

"Looks like we won't be able to get near the fortress."

"Don't they all have our wanted poster?"

Rayon and Pen didn't know what to do.

"I've got it! What if we disguised ourselves?"

Marble suggested to the others.

"A disguise contest! We can all go as whatever we want—woof!"

Book seemed to really like the idea.

"Wh-What should I go as?"

The big monster asked apologetically.

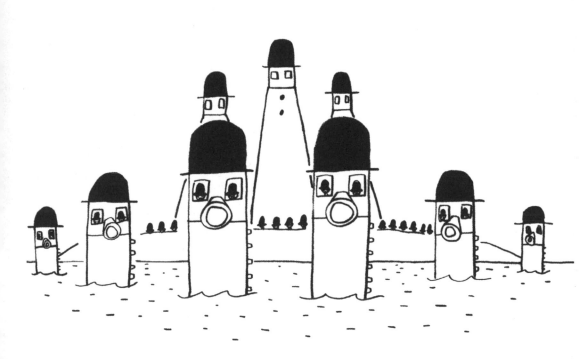

SMALL HINT!

Let's draw beards and moustaches

Let's draw masks

Let's draw glasses

Let's draw wigs

Let's draw hats

Let's draw horns

let's draw!

"Who are all of you?"

The toy soldiers were confused.

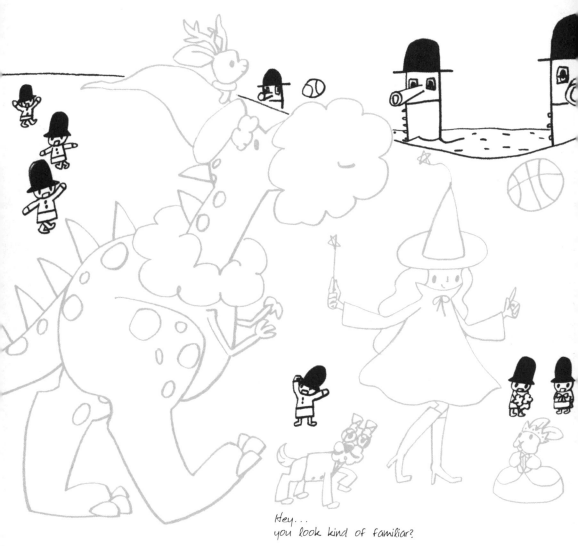

Hey...
you look kind of familiar?

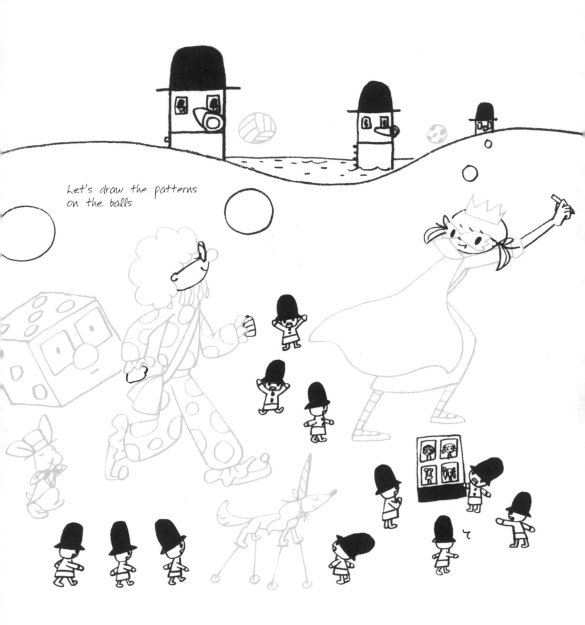

Let's draw the patterns
on the balls

The Maze of Mirrors

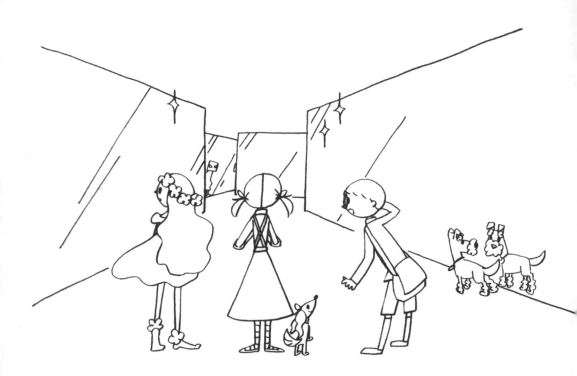

Once they had snuck into the fortress, they found themselves in a maze of mirrors.

(clank!!)

"Yowww... That was just my own reflection in the mirror..."

They couldn't seem to figure out which way was the path and which way was only mirrors.

They were standing there, stock-still, when a strange shadow cut in front of them.

"Was that one of the Eraserheads?"

"He's running that way!"

"No, that's just a mirror, not the path—it must be this way!"

"This is so complicated!"

SMALL HINT!

Let's draw reflections in the mirror

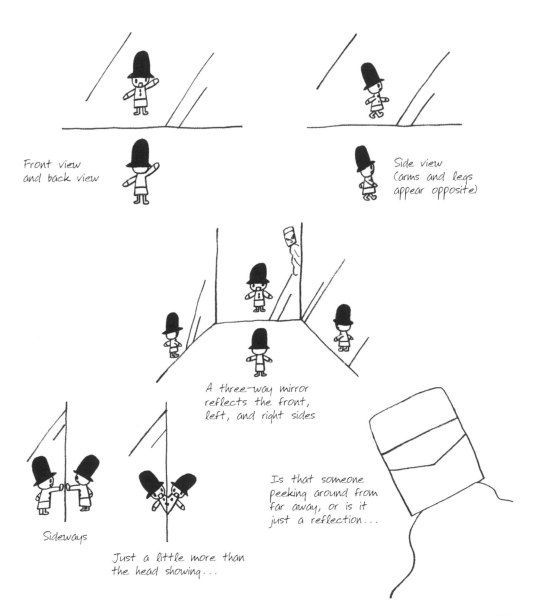

Front view
and back view

Side view
(arms and legs
appear opposite)

A three-way mirror
reflects the front,
left, and right sides

Sideways

Just a little more than
the head showing...

Is that someone
peeking around from
far away, or is it
just a reflection...

let's draw!

"But which way should we go?"

"Hey everyone! This way!"

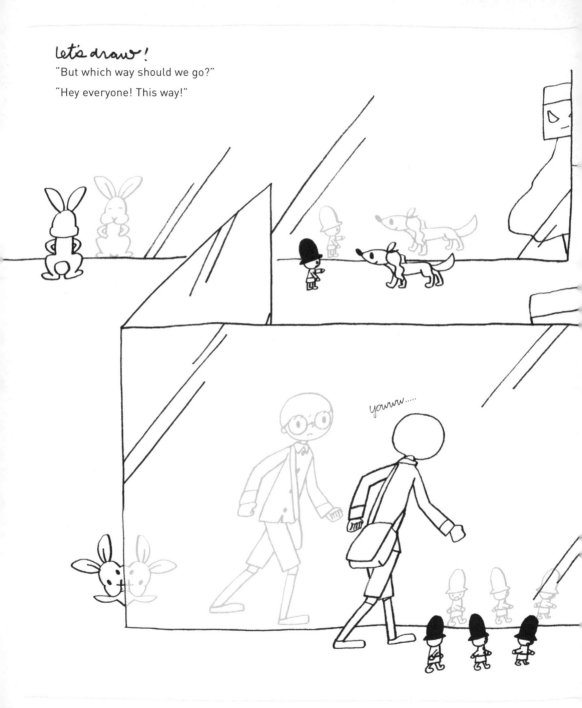

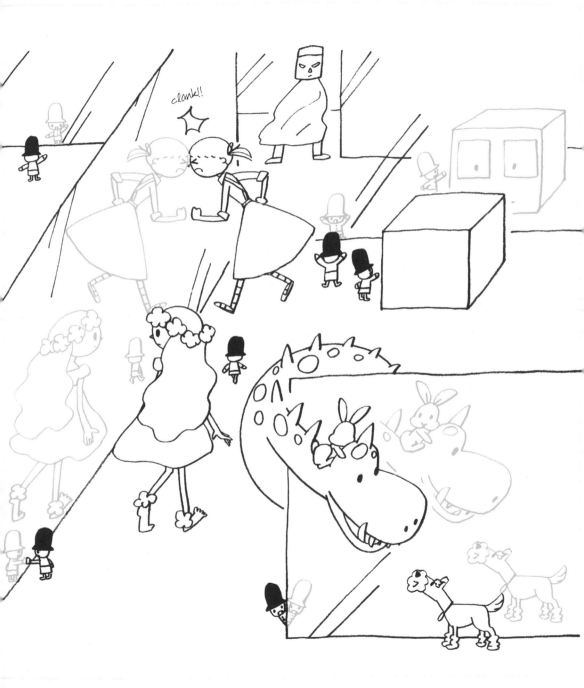

SCENE 28
Fire Ghosts and Water Ghosts

Once they emerged from the hall of mirrors, they found themselves in a long passageway.

They hadn't realized it, but the toy soldiers were following them, and one of them said,

"You know... there are scary ghosts inside here."

Something was watching them from around the corner at the end of the passageway.

"It's true—woof! That looks like a ghost over there."

Book was wagging his tail excitedly.

"I'm going to burn all of you up!"

"No, I'm going to freeze all of you up!"

"Me first!"

"No, me first!"

The fire ghost and the water ghost got into an argument about who would go first.

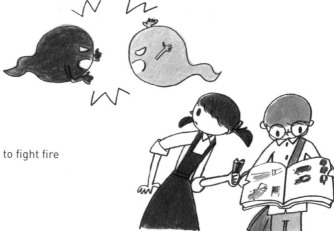

Meanwhile, Pen looked up ways to fight fire and ice...

And now, the final battle!

SMALL HINT!

Let's draw fire

It flickers

Draw the outer flames

Draw the inner flames

Draw the sparks

Let's draw fire fanned by the wind

Flame on a gas burner

It burns blue and straight

Let's draw water

Water takes the shape of its vessel, or it depends on the speed at which it is flowing

Let's draw water that looks like liquid

Press down with your pencil in swift strokes

Or you can sprinkle drops all over

let's draw!

"We've got to use water to put out the fire!"

Let's spray plenty of water from hoses and squirt guns.

"Leave the wall of ice to me!"

The monster breathed fire from his mouth!

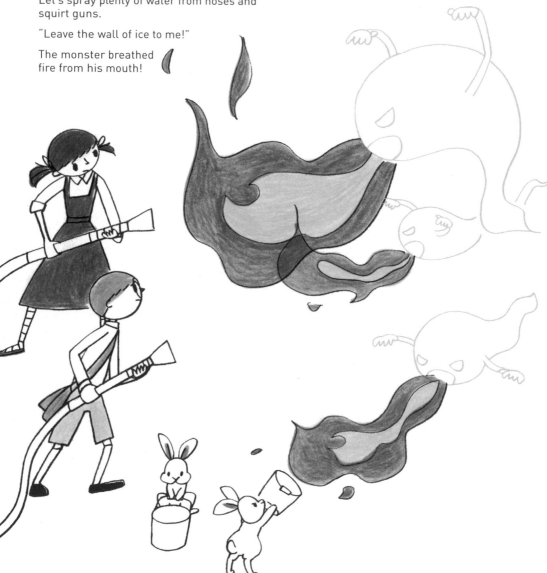

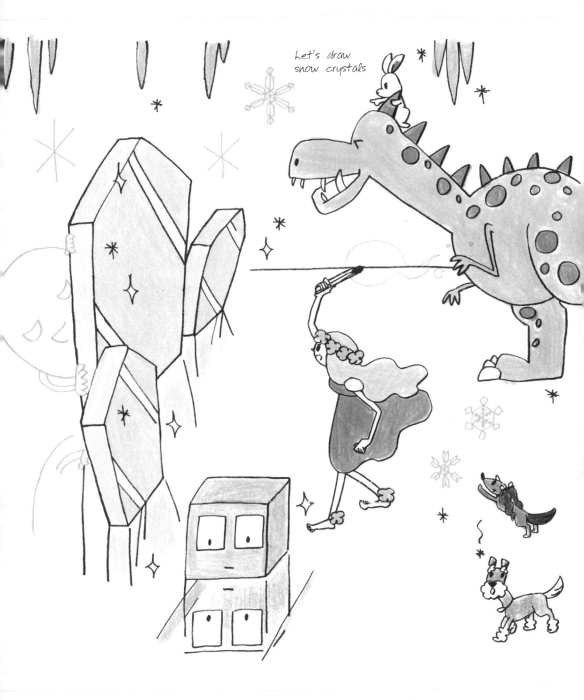

Let's draw
snow crystals

SCENE 29
The Final Battle!?

Pen and Rayon and the others had reached a big shadowy room.

"Bwa-ha-ha... So you cowardly kids have finally made it all the way here... Bwa-ha-ha!"

"Ho-ho-ho... Should we give them lots of candy to rot their teeth...? Ho-ho-ho!"

Eerie voices came from inside the room.

"Bwa-ha-ha... You'll never be able to defeat us!"

"Ho-ho-ho... That's right, because we've got erasers that can erase anything!"

It grew brighter over where the voices were coming from, and now they could see figures with square erasers on their heads.

"No matter how many messy little doodles you draw, we'll just erase them all!"

"Bwa-ha-ha... "

"Ho-ho-ho... "

"I don't care how many times you erase me! I'll just keep redrawing my world over and over!!" Pen shouted.

"I'm not going to let you do that! And who says our drawings are messy?!" Rayon yelled.

"Yeah, right! There's nothing we can't redraw—woof!" Book said.

"Uh-huh! Takes one to know one!" Marble added.

The Eraserheads automatically covered their ears.

"Ah, that's enough—be quiet! This is why I hate kids and dogs..."

"We'll give you candy, just stop your silly nonsense and leave us in peace!!"

_____ had an idea.

"I've got it! They hate loud noises. So let's all start singing and dancing and make a big ruckus!"

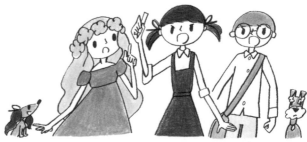

SMALL HINT!

Guitar

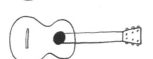

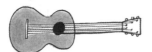

The hole goes in the middle toward the neck

There are six strings

Cymbals

Draw the handles and show the contours
Two make a set

Piano keys

First draw the white keys

Then add the black keys

Trumpet

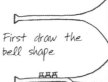

First draw the bell shape

Then add the pipe and the valves

Drums

Tambourine

Harmonica

Let's draw sounds

Boom-boom

Sounds expand as they travel from the source

La-la-la

let's draw!

"Be quiet! You're disturbing the neighborhood!" "Stop doing that! Stop it now!"

The more upset the Eraserheads got, the more noise Pen and Rayon and the others made!

Let's draw! Nobody can compare with my drawings!

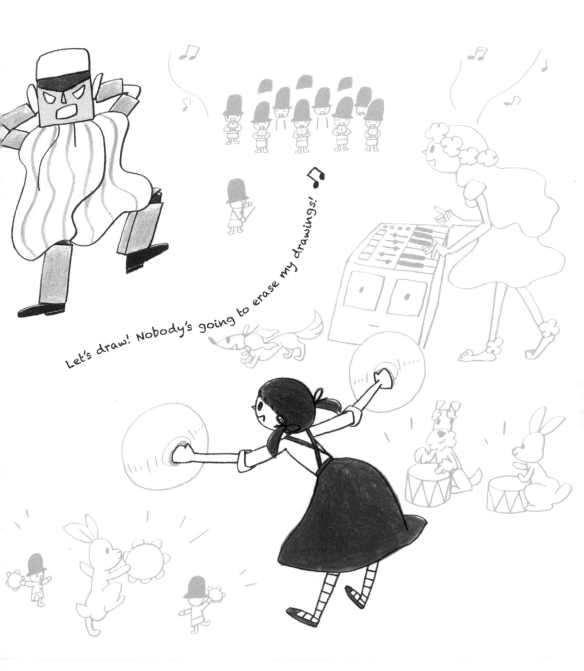

Let's draw! Nobody's going to erase my drawings!

epilogue

"Stop it! Be quiet! You're disturbing the neighborhood!"

"I can't take it anymore! That's enough! We'll get you next time! Don't forget it!"

And the Eraserheads ran off, covering their ears.

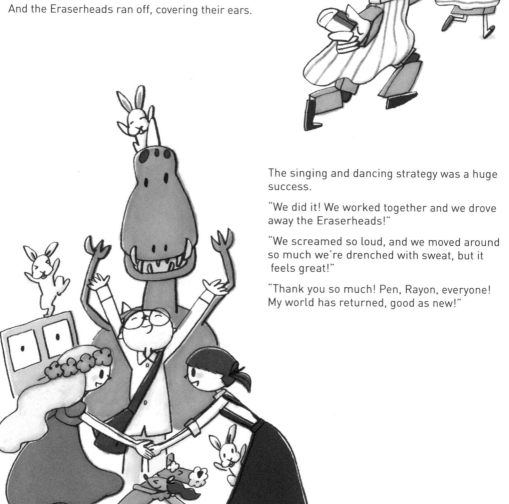

The singing and dancing strategy was a huge success.

"We did it! We worked together and we drove away the Eraserheads!"

"We screamed so loud, and we moved around so much we're drenched with sweat, but it feels great!"

"Thank you so much! Pen, Rayon, everyone! My world has returned, good as new!"

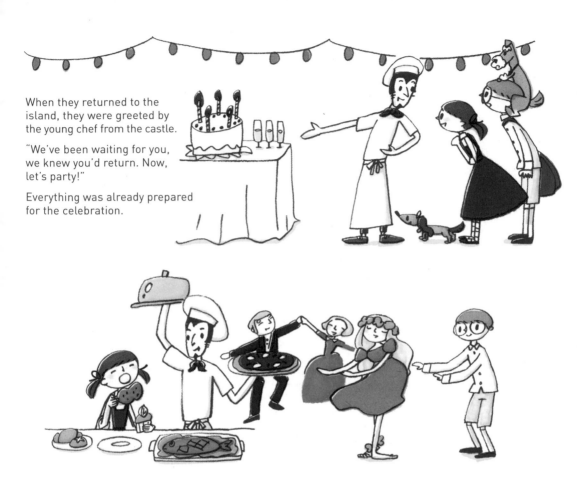

When they returned to the island, they were greeted by the young chef from the castle.

"We've been waiting for you, we knew you'd return. Now, let's party!"

Everything was already prepared for the celebration.

"Okay, sing and dance all you want!"

"And eat your fill!"

The toy soldiers and the ghosts joined the party too, as if there had been nothing between them and the others.

"Well, I feel pretty good. Tee-hee-hee!"

"Ha-ha-ha, Me too!"

Book and Rayon laughed together.

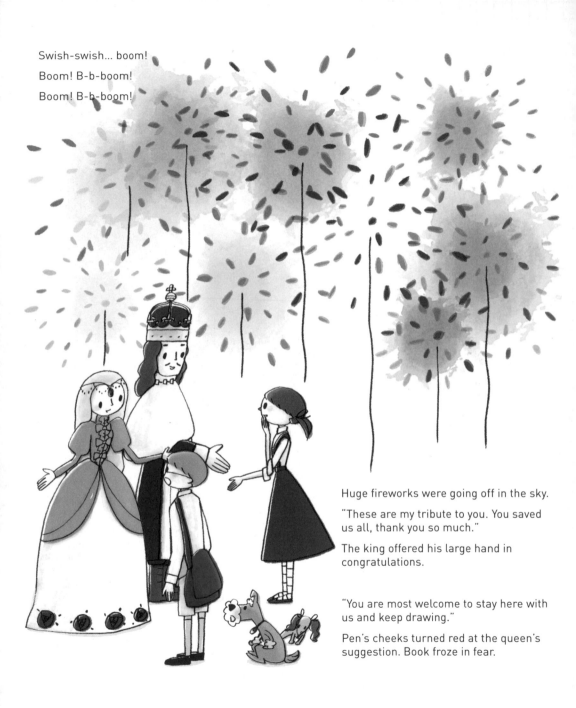

Swish-swish... boom!

Boom! B-b-boom!

Boom! B-b-boom!

Huge fireworks were going off in the sky.

"These are my tribute to you. You saved us all, thank you so much."

The king offered his large hand in congratulations.

"You are most welcome to stay here with us and keep drawing."

Pen's cheeks turned red at the queen's suggestion. Book froze in fear.

The twins looked around at all the people gathered there, and nodded at each other.

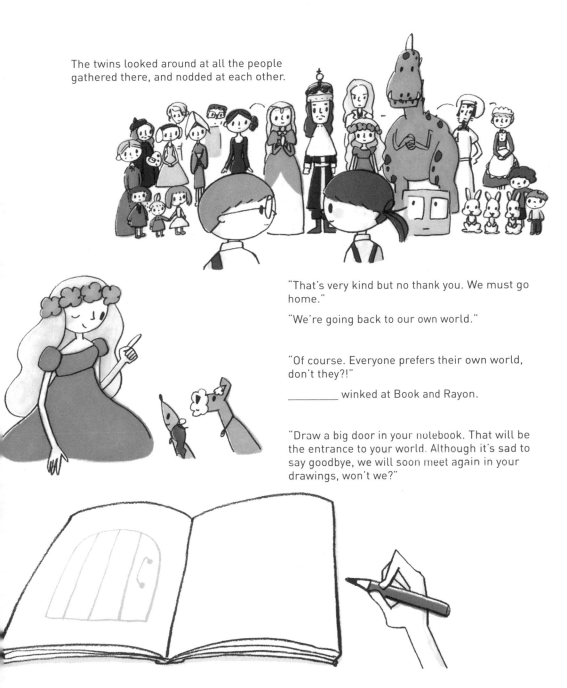

"That's very kind but no thank you. We must go home."

"We're going back to our own world."

"Of course. Everyone prefers their own world, don't they?!"

_____ winked at Book and Rayon.

"Draw a big door in your notebook. That will be the entrance to your world. Although it's sad to say goodbye, we will soon meet again in your drawings, won't we?"

Rayon drew a door in her notebook, and it grew bigger and bigger before their eyes, until a big door appeared before them.

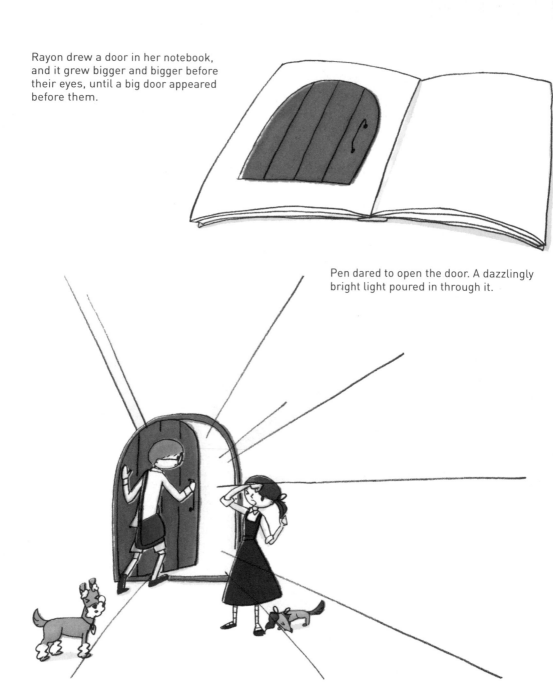

Pen dared to open the door. A dazzlingly bright light poured in through it.

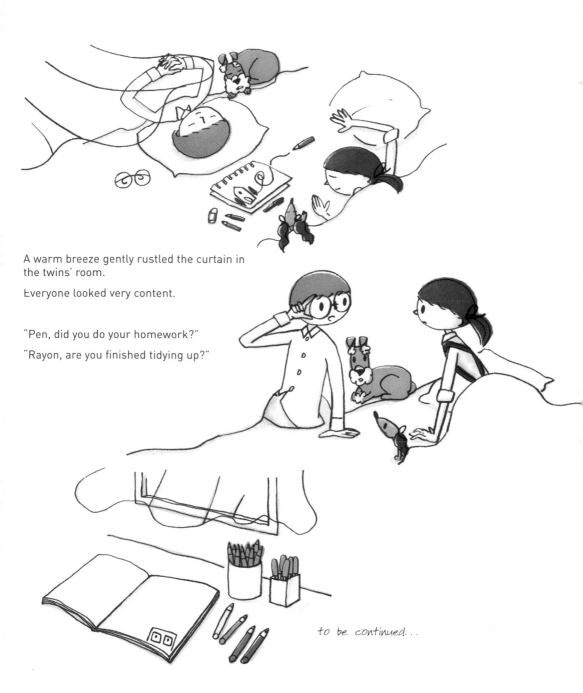

A warm breeze gently rustled the curtain in the twins' room.

Everyone looked very content.

"Pen, did you do your homework?"

"Rayon, are you finished tidying up?"

to be continued...

Sachiko Umoto

Sachiko Umoto, born in 1970, graduated with a degree in oil painting from Tama Art University (Tokyo). In addition to her work as an illustrator, she also produces animation works for USAGI-OU inc. She is the author of *Illustration School: Let's Draw Cute Animals, Illustration School: Let's Draw Happy People, Illustration School: Let's Draw Plants and Small Creatures*, and *Illustration School: Let's Draw Magical Color* (all originally published in Japan by BNN, Inc.).
She dearly loves dogs and Hawaii. Recently, because of her twins, she has become very interested in the Super Sentai Heroes. Visit her online at http://umotosachiko.com.